Remembering
Reno

Donnelyn Curtis

TURNER
PUBLISHING COMPANY

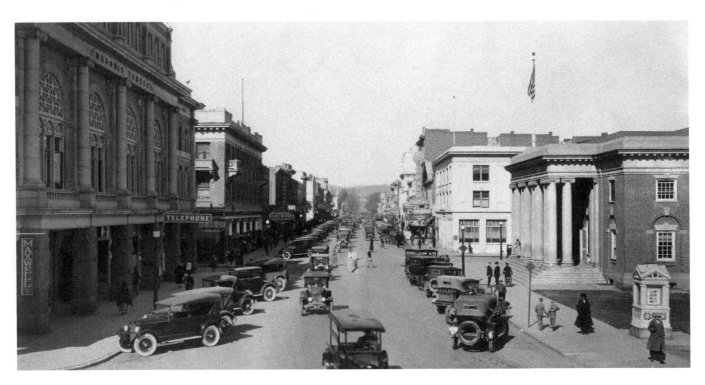

Virginia Street, in the heart of the business district, toward the north from the Truckee River in the early 1920s. The post office is on the right.

Remembering
Reno

Turner Publishing Company
4507 Charlotte Avenue • Suite 100
Nashville, Tennessee 37209
(615) 255-2665

Remembering Reno

www.turnerpublishing.com

Library of Congress Control Number: 2010926202

ISBN: 978-1-59652-676-1

Printed in the United States of America

ISBN: 97-1-68336-877-9 (pbk)

CONTENTS

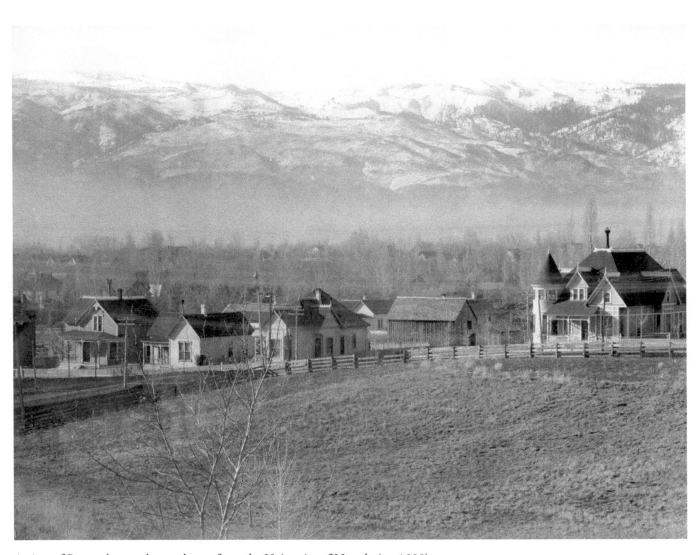

A view of Reno taken to the southwest from the University of Nevada (ca. 1898).

Acknowledgments

This volume, *Remembering Reno,* is the result of the cooperation and efforts of many individuals and organizations. It is with great thanks that we acknowledge the valuable contribution of the following for their generous support:

Shane Anderson
Library of Congress
University of Nevada, Reno, Basque Studies Library
University of Nevada, Reno, Special Collections and University Archives

We would also like to thank the following individuals for valuable contributions and assistance in making this work possible:

Kathryn Totton, Photo Archivist in Special Collections at the University of Nevada, Reno Libraries and an expert on Nevada history
James Bantin, University Archivist in Special Collections at the University of Nevada, Reno Libraries
Melissa Rivera, the student assistant in Special Collections who digitized most of the photographs
Dr. James Herz, the avid collector and generous donor of the majority of the photos in this book, whose own research efforts provided important clues to the stories of the photos
Dr. Anton Sohn of the University of Nevada School of Medicine, for sharing his History of Medicine in Nevada photos
The many photographers who documented Reno's history so beautifully, and the many donors who lovingly preserved and generously provided the photographs to Special Collections

PREFACE

Reno has always been a colorful city in an unconventional state. Conversely, the majority of the population has led conventional lives outside of the neon corridor. Several novelists and historians have observed that Reno is full of parallel universes. Photographers have documented the orderly development of a western metropolis, as well as some of the aspects that have earned Reno its sometimes scandalous reputation. Taken as a whole, the photographs in this book illustrate the multi-faceted character of "the Biggest Little City in the World."

The intent of this book is to let photographs speak for themselves in presenting the history of Reno, with minimal interpretation. In selecting the images, our researchers have made every effort to portray the broad and comprehensive view of the city's past. We have painstakingly probed the corners of photo archives to uncover depictions of the lesser-known, the surprising, and the unique aspects of the history of Reno.

The photographs are presented in approximate chronological order, grouped together within eras of Reno's history. Short introductions describe the eras to provide historical context. The captions add details about the individual photos to help readers understand the times, places, and circumstances depicted. Most of the photographs in the book were selected from the rich photo archives of Special Collections at the University of Nevada, Reno Library.

With the exception of touching up imperfections that have accrued with the passage of time and cropping where necessary, no changes have been made. The focus and clarity of many images are limited to the technology and the ability of the photographer at the time they were recorded. On behalf of future historians, the author urges readers to label their treasured photographs! The people, locations, times, and events portrayed in your photo album might be familiar to you, but 50 years after your demise, those facts may be lost forever.

The photographs in the first section cover Reno's early history, from the 1860s through 1909. The second section explores the time period 1910–1929, when Reno was developing its personality (or rather,

multiple personalities). Section Three, 1930–1949, documents a period of adjusting to new economic conditions and new approaches to economic development. Section Four, 1950–1970s, covers Reno's further growth and maturation. In each of these sections we have attempted to capture the many facets of Reno's personality.

Through this project, the author has developed a heightened appreciation and gratitude for the work of historians who have previously done such meticulous research on Reno's history, without the benefits of contemporary online tools.

We encourage readers to view contemporary Reno with these historic images in mind. How can we protect and preserve the fragments of the past that help us understand the present and plan for the future? Photographs preserve the past and provide pleasure, but they can serve another purpose as well: they can help us discern the remnants of earlier times that are still with us—though sometimes overshadowed— within our present environment.

—*Donnelyn Curtis*

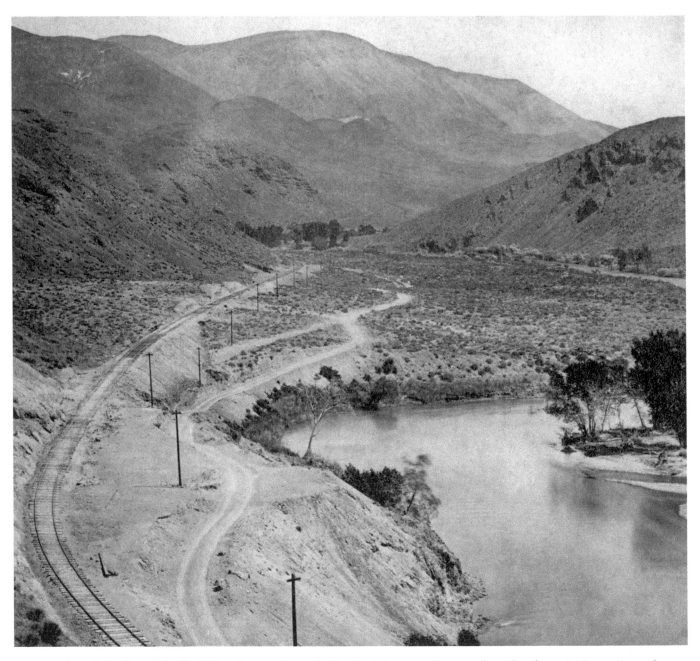

Construction of the Central Pacific Railroad tracks along the Truckee River east of Reno. The railroad stop in Reno triggered the town's permanent settlement.

HUB OF THE MINING BOOMS

(1860s–1909)

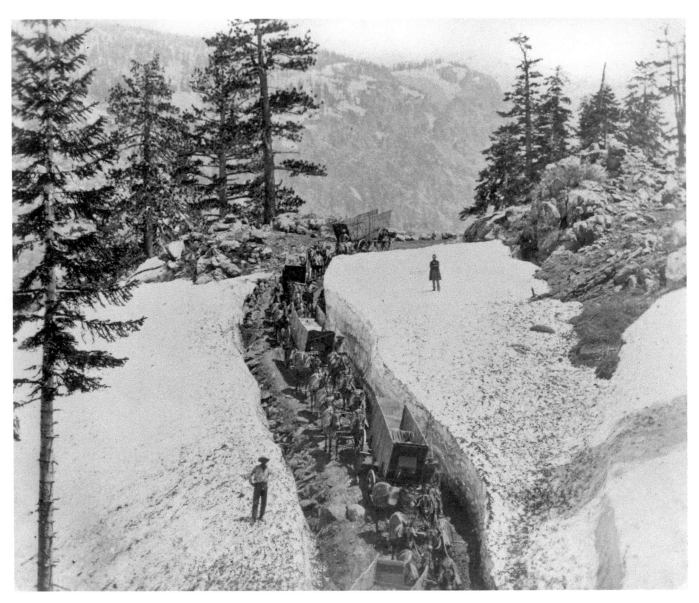

Freight wagons, men, and teams of the Sierra Nevada Transport Company on a road through the snow in the Donner Pass of the Sierra Nevada in early spring (ca. 1896).

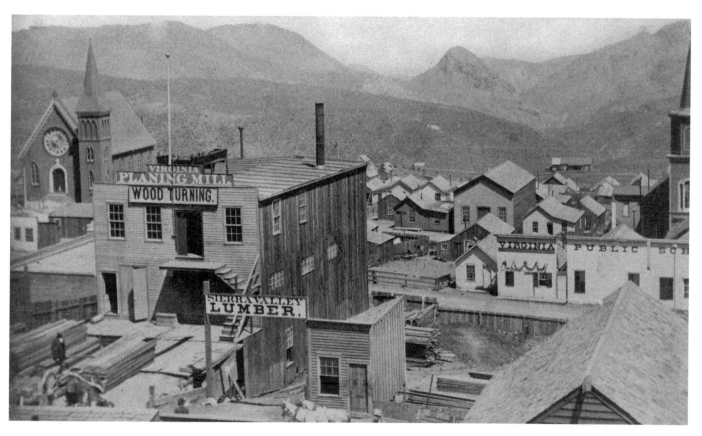

A view of Six-Mile Canyon from C Street in Virginia City in 1865, when Reno was little more than a river crossing. Proximity to this larger town aided Reno's growth as a transportation hub and, after the 1880 depression, it surpassed the declining Virginia City.

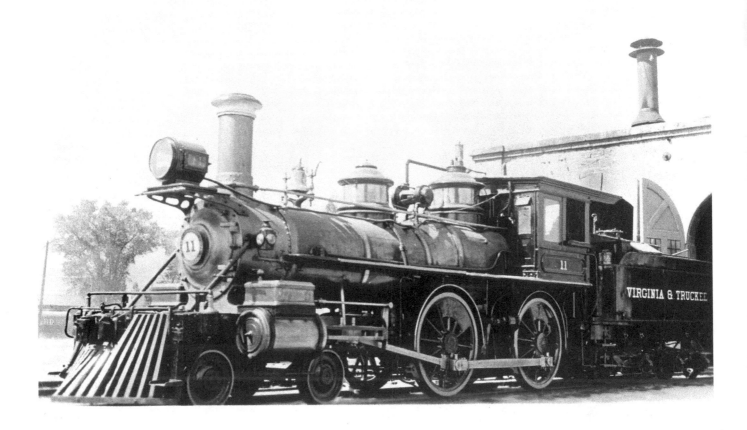

Engine no. 11 of the Virginia and Truckee Railroad at a roundhouse in Carson City in the late 1800s. The V&T, the "crookedest short line in America," connected in Virginia City with the Central Pacific Railroad in Reno in 1879. In the beginning, 36 trains a day carried passengers and freight. Lumber from Carson Valley mills and supplies were transported to Virginia City, and ore was hauled on the return runs to Reno.

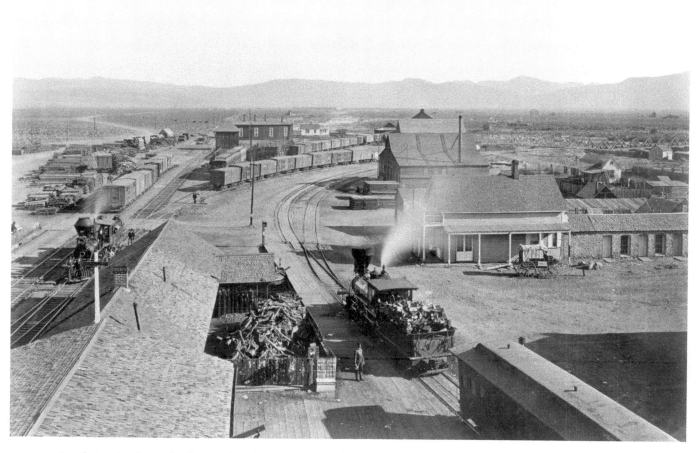

A rather quiet day at the Reno railroad yard. In 1885, the Central Pacific line was leased to the Southern Pacific Railroad.

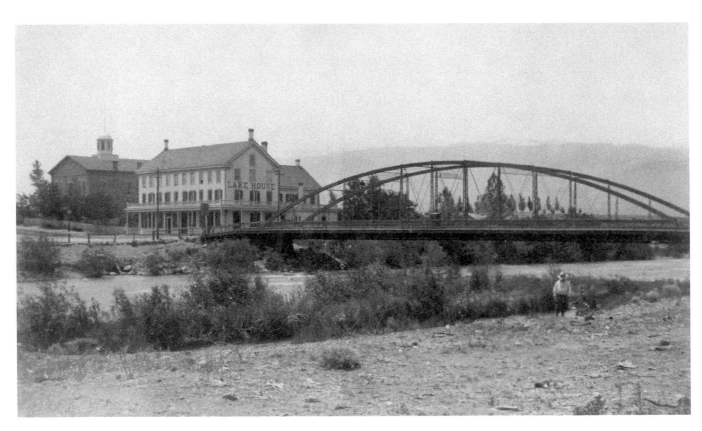

Myron Lake's hotel and the first iron bridge across the Truckee River. At the south end of the bridge, Virginia Street passed the Lake House, later renamed the Riverside. At the north end of the bridge, Virginia Street crossed Front (later renamed First) Street.

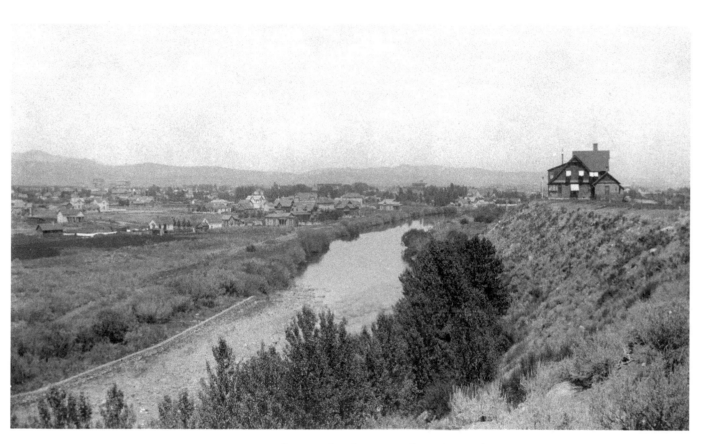

A photographer facing east along the Truckee River shot this early image of Reno.

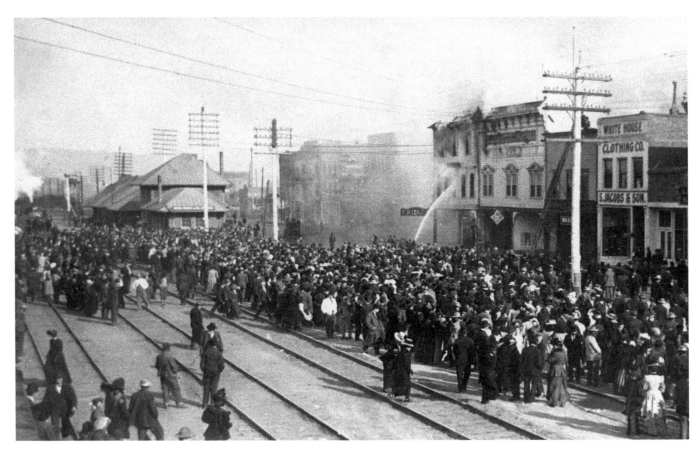

A fire at the Palace Club, the largest gambling house in the state, attracted a large crowd. There were no restrictions on gambling in Reno until 1910. The railroad depot is in the background.

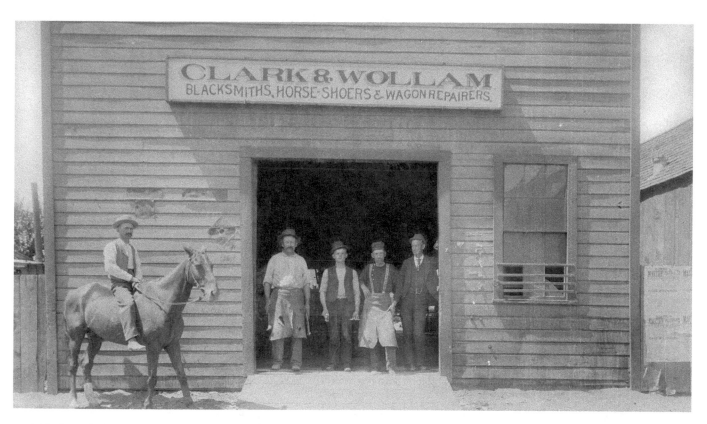

A blacksmith shop on Center Street, 1893. The two men in the center are identified as Baldwin and S. E. Cooper, a blacksmith. The Golden Hotel was built on this site in 1906. A fire in 1962 destroyed the Golden Hotel and killed six people. The 24-story hotel that was rebuilt in 1963 was purchased by Bill Harrah three years later and became part of Harrah's.

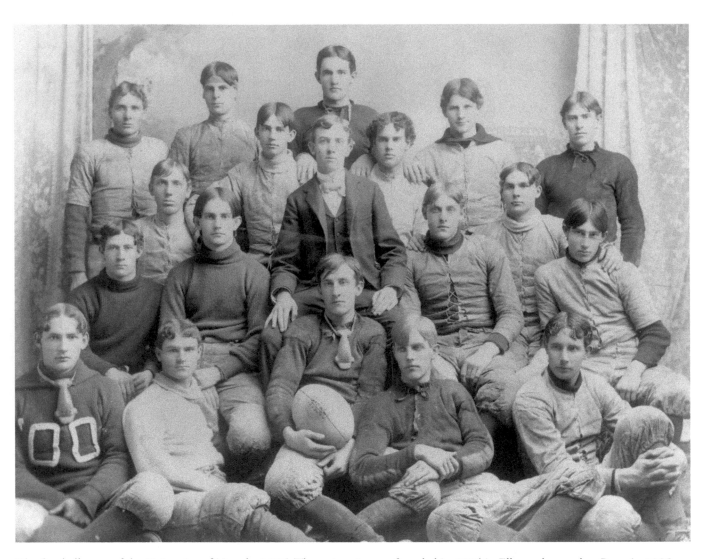

The football team of the University of Nevada, 1896. The university was founded in 1874 in Elko and moved to Reno in 1885. For 75 years the university was Nevada's only institution of higher education.

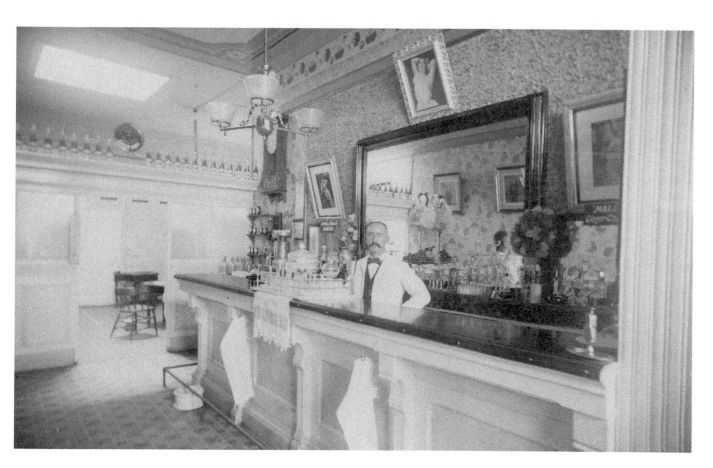

The interior of a bar in Reno in the 1800s.

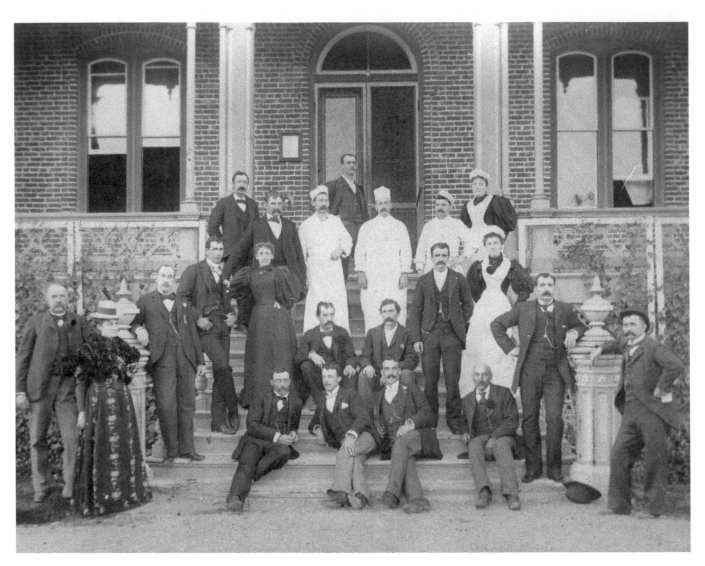

The house staff of the Nevada Hospital for Mental Disease, which opened in 1882 (ca. 1890). Patients did agricultural work on the property, which eventually housed the university farm.

The Fulton house was built in Virginia City in 1875 and later abandoned when fortunes changed. It was purchased, dismantled, moved to Reno, and reassembled on the bank of the Truckee River on West First Street in 1884 by Robert Fulton, the owner of the *Reno Gazette* newspaper. The property later became the Reno city park directly across the river from Trinity Episcopal Church.

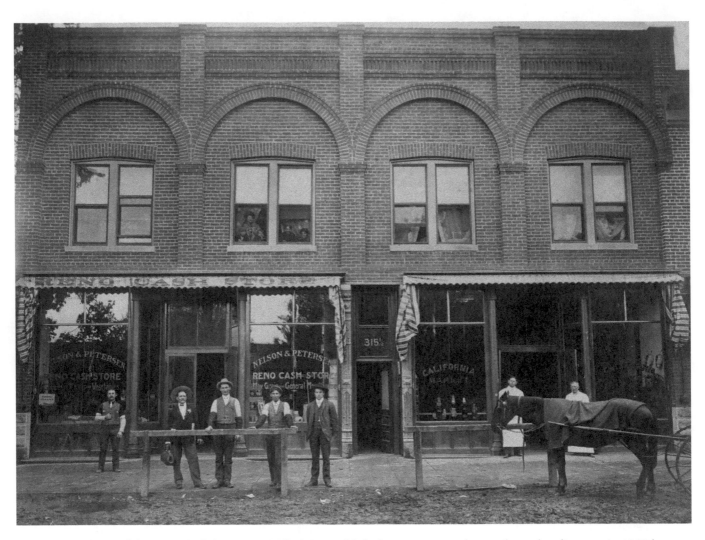

Employees in front of the Reno Cash Store at 315 Virginia, established as a grocery and general merchandise store in 1903 by Robert Nelson, a city councilman. Ross Peterson was an early partner until 1915. The name of the store was later changed to the California Market. It closed in 1959.

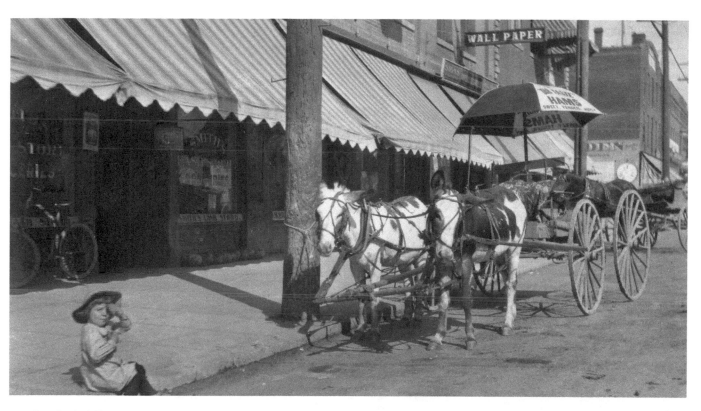

A butcher's delivery wagon in front of Smith's Cash Store at 129 Virginia Street around 1904. Half the store was a butcher shop, and for several years it served as the only retail butcher outlet.

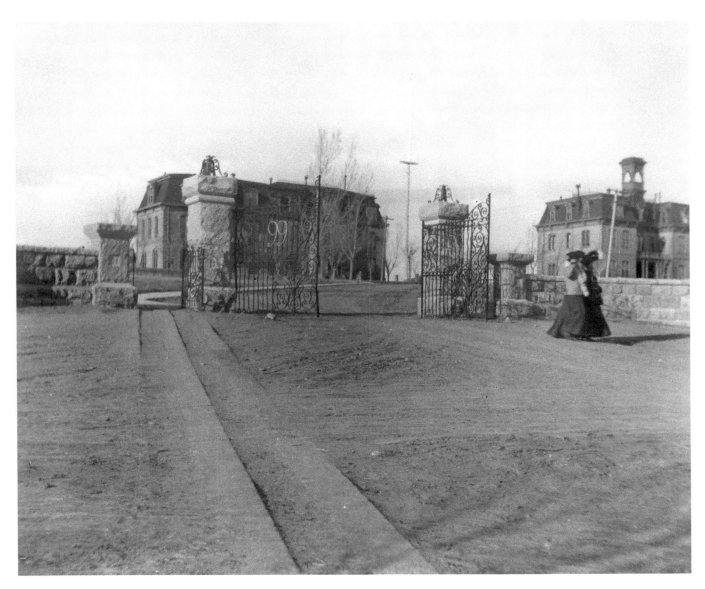

The entrance to the University of Nevada, Reno, near the beginning of the twentieth century. On the left is the Hatch Building, originally the State Mining Laboratory, standing in front of Stewart Hall, which was used for classes and as a dormitory. On the right is Morrill Hall, the first building on campus (still standing and in use), built in 1886 and named for the Vermont senator, Justin Morrill, who was the author of the land-grant act establishing the university.

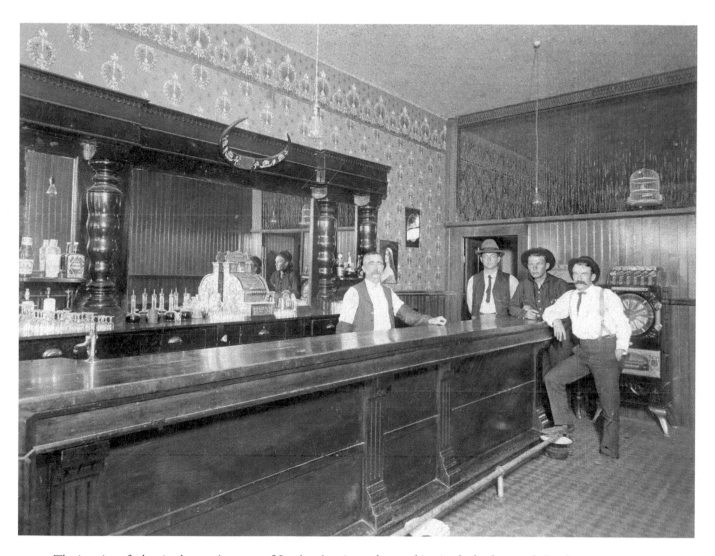

The interior of a bar in the nearby town of Sparks, showing a slot machine in the background, Sparks, now contiguous with Reno, was established in 1904 when the Souther Pacific Railroad moved its switch year and maintenance buildings, along with the houses for workers, to the area. The town was named for John Sparks, the governor of Nevada at the time. The estimated population of Sparks in 2005 was 82,051.

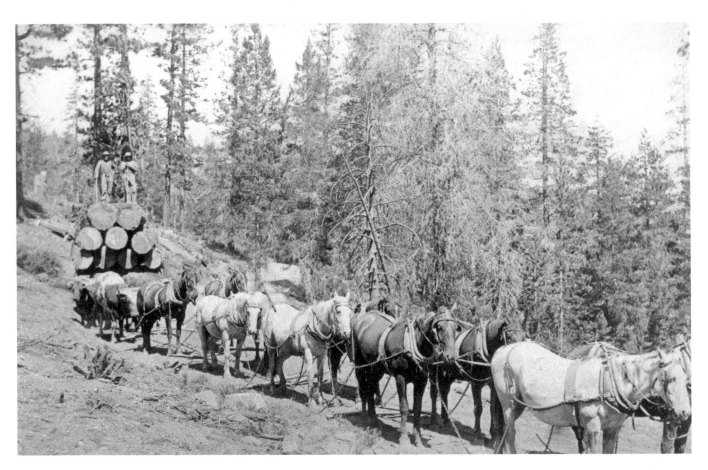

Teamsters haul logs from the Tahoe area in the early 1900s. The fast-growing town depended on lumber brought in from the nearby mountain forests.

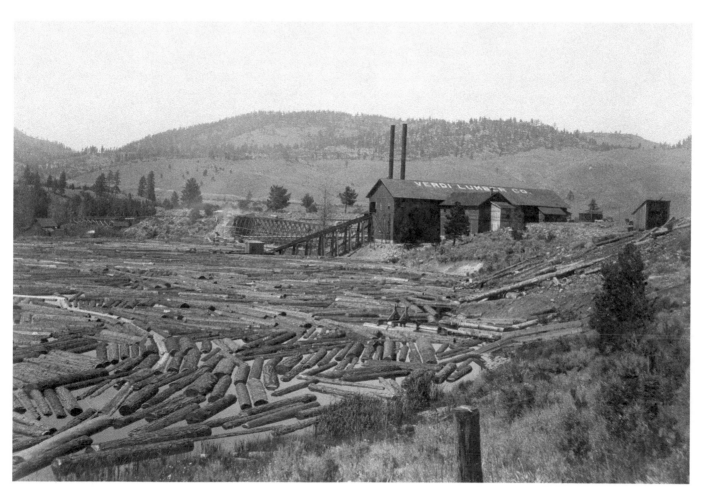

Sierra logs await processing in the pond of the Verdi Lumber Company sawmill, located 15 miles to the west of Reno, around 1904.

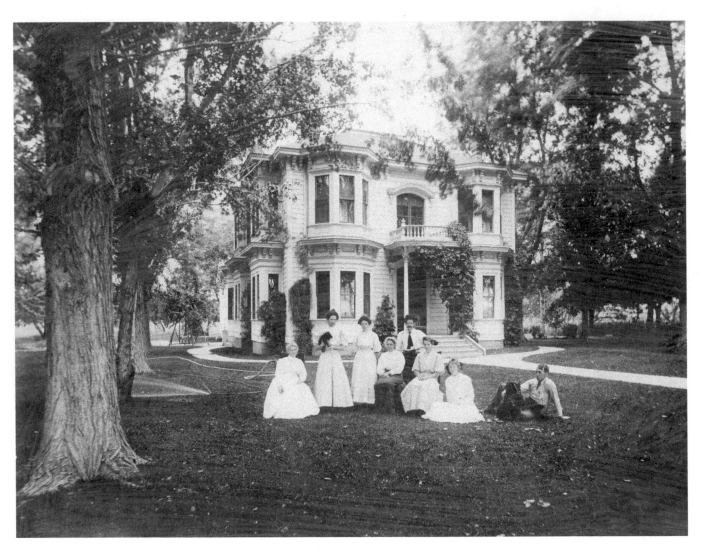

The John Newton Evans house in 1905, at the south edge of what would become the University of Nevada, Reno. Evans, a prominent banker, was instrumental in relocating the university from Elko to Reno, selling the land upon which the campus was built. In 1925 the house on Evans Avenue was sold to the Sigma Alpha Epsilon fraternity. It was later replaced by another building. The adjacent Evans property became a city park.

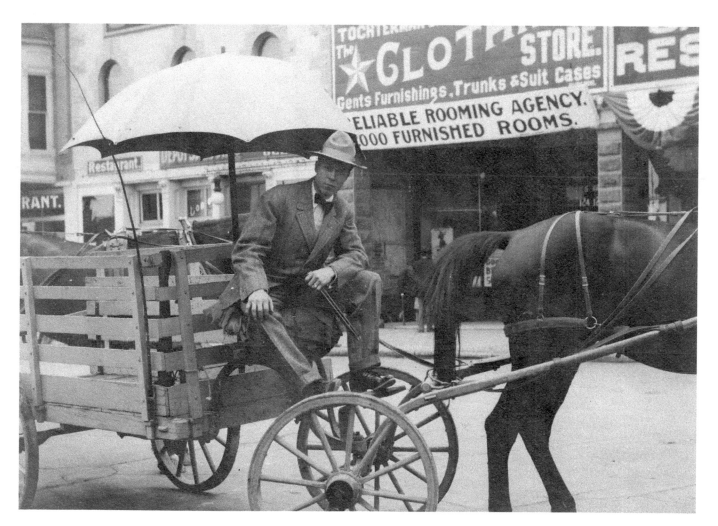

A horse and wagon in Reno's commercial district in the early 1900.

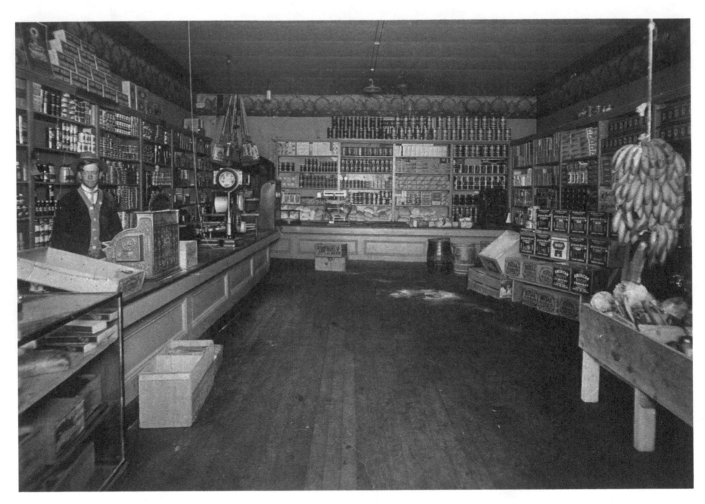

The interior of a grocery store in Reno, stocked with boxes of Sunny Monday laundry soap and Royal Swastika brand sodas from American Biscuit Company. The swastika was an honored symbol among Native American tribes long before Nazi Germany corrupted its meaning.

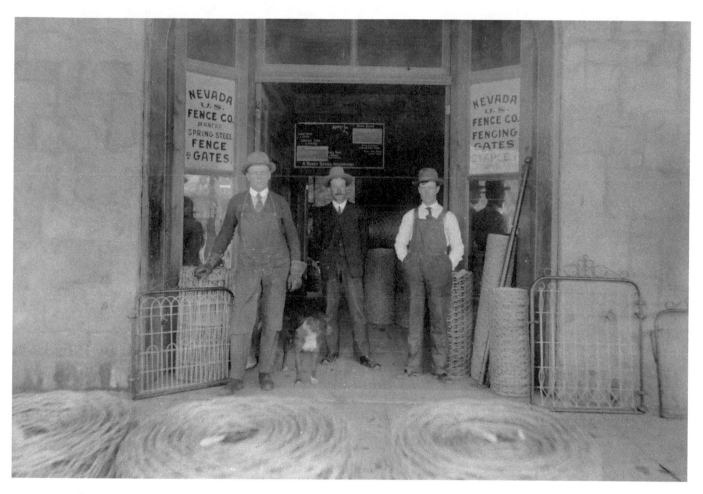

During the many years of unregulated open grazing, it was necessary for ranchers to protect their water supplies from itinerant herds, as well as wild horses. Once open grazing became regulated and much more limited, fencing was needed to contain ranch livestock. The sign inside promotes fencing for lawns and cemeteries as well.

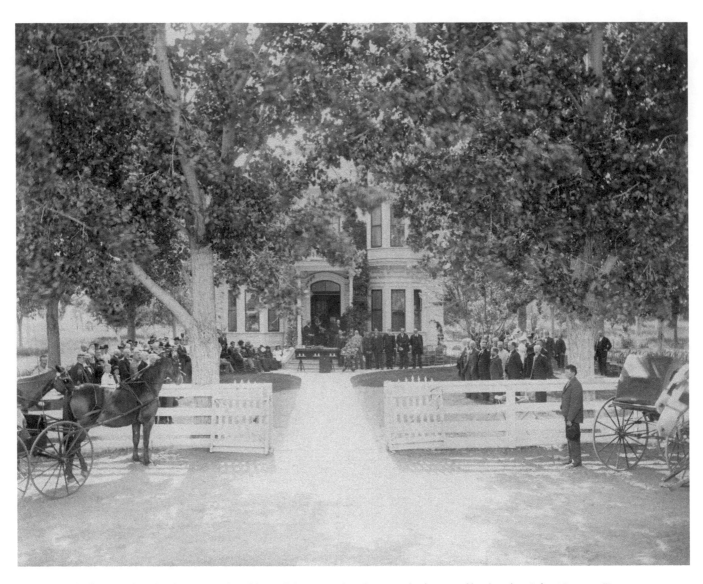

The funeral of General Orlando Evans, the oldest of the Evans brothers, at the house of his brother John Newton Evans, 835 Evans Avenue.

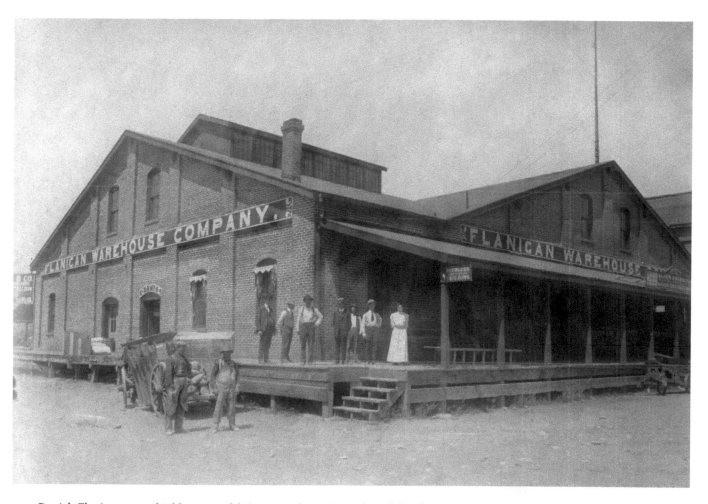

Patrick Flanigan was a highly successful sheep rancher in Nevada and California. He was the first sheepman in Nevada to ship wool directly to Chicago and Kansas City from the Flanigan Warehouse in Reno on East Fourth Street. His Nevada Packing Company processed large quantities of meat from area ranchers. Flanigan was instrumental in producing electric power for the area and was active in Nevada politics.

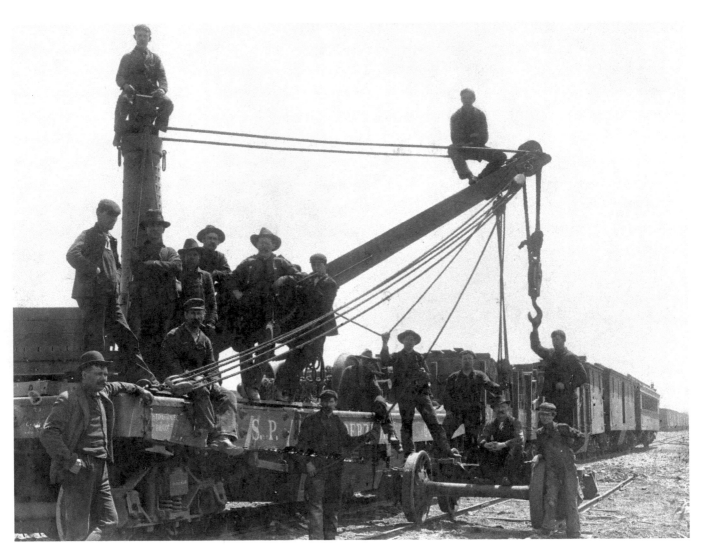

A Southern Pacific Railroad work crew poses with heavy equipment. Reno's role as a railroad hub kept its economy relatively stable as mining waned.

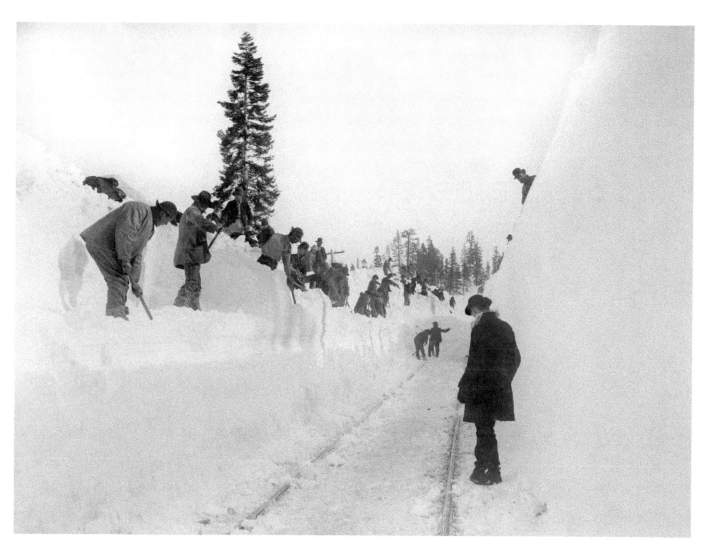

Clearing snow from the Southern Pacific railroad tracks in the Sierra Nevada between Reno and Sacramento could be a monumental job.

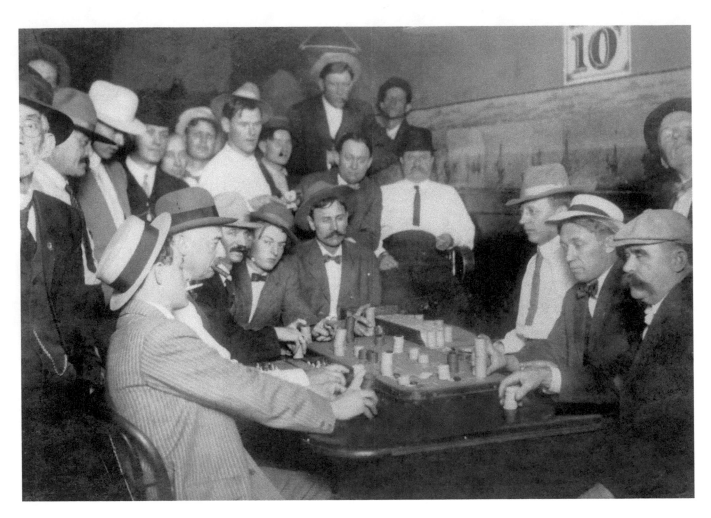

A game of faro in a Reno casino, October 8, 1910.

EMERGING PLAYGROUND

(1910–1929)

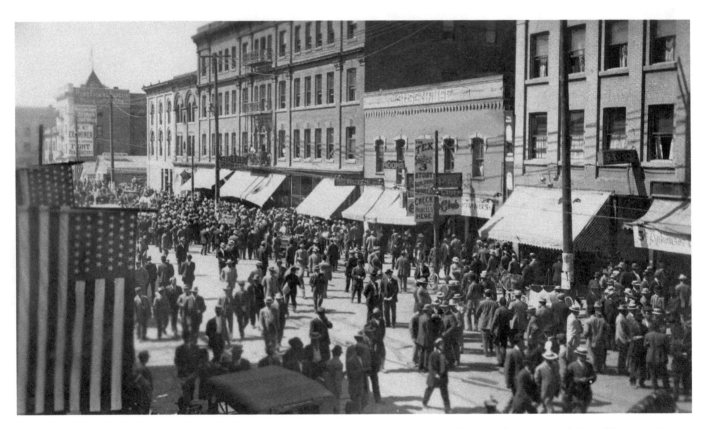

The day of the Jack Johnson–Jim Jeffries fight in Reno, July 4, 1910. The event was the most famous prizefight of the time. It exacerbated racial tensions across America and focused the country's attention on Reno.

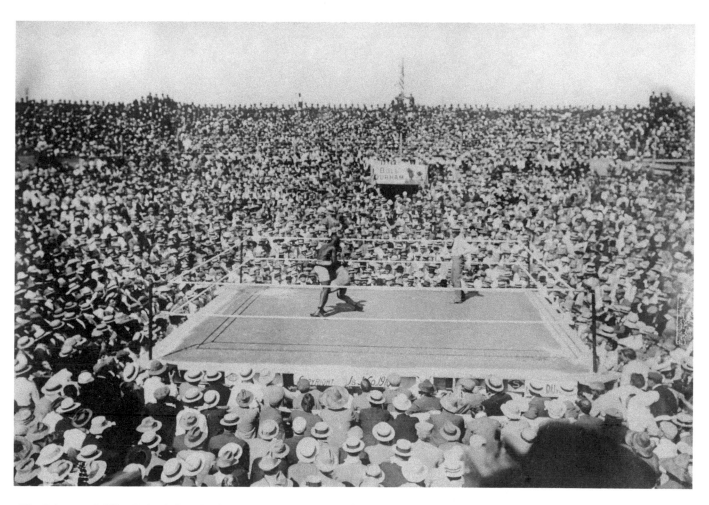

The Johnson–Jeffries Fight, help July 4, 1910, was called the Fight of the Century. After San Francisco canceled the fight between Jack Johnson, the first black heavyweight champion of the world, and Jim Jeffries, a former champion, Reno had two weeks to build a stadium and prepare for more than 22,000 spectators who attended the match.

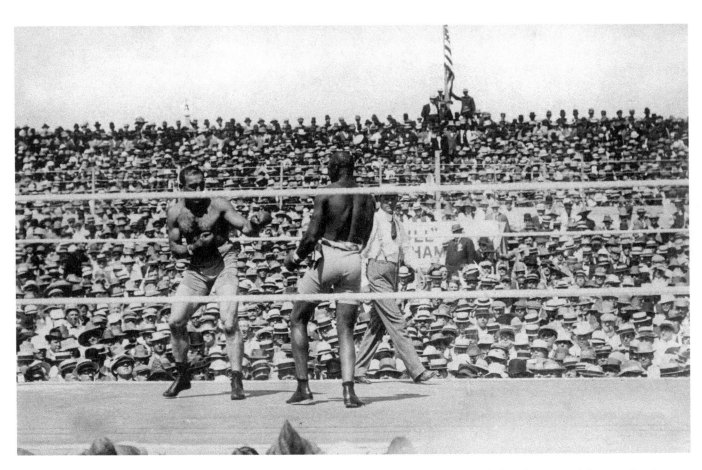

The outcome of the fight triggered riots all over the country, as angry whites clashed with blacks who were celebrating the victory.

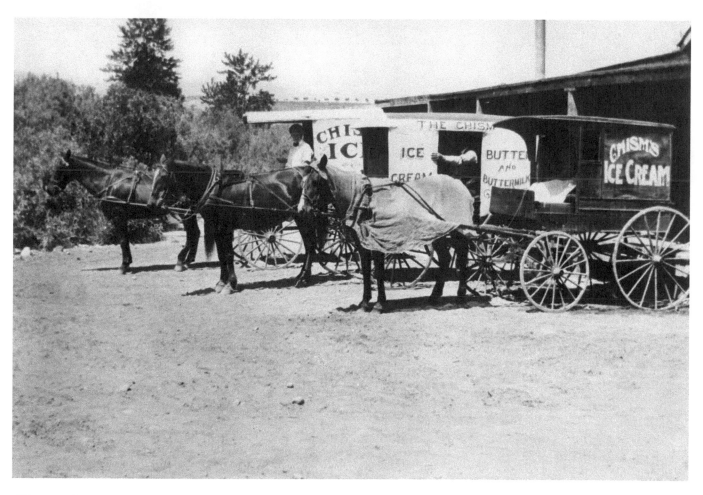

Chism Ice Cream wagons, 1912. Edward Chism established the ice creamery in 1905, while his brother John ran the Chism Dairy (later the Crescent Dairy) from 1900 until the 1950s. By 1904, the family owned the largest number of milk cows in the State of Nevada. After buying the ice cream company in 1960, Carnation continued to use the Chism name locally until the 1970s.

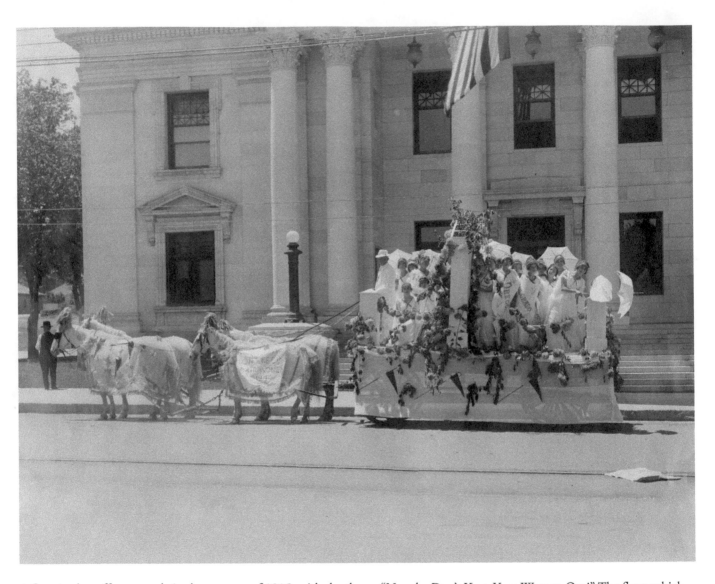

A float in the suffrage parade in the summer of 1915, with the theme "Nevada, Don't Keep Your Women Out!" The float, which was awarded the $25 second prize, represents "Nevada standing at the gate waiting to be admitted to her free sisters." It is resting in front of the courthouse.

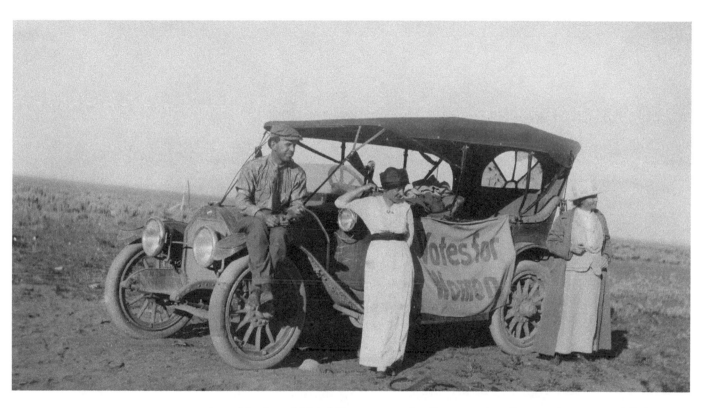

Anne Martin and Mabel Vernon campaign for women's suffrage in their automobile in 1914.

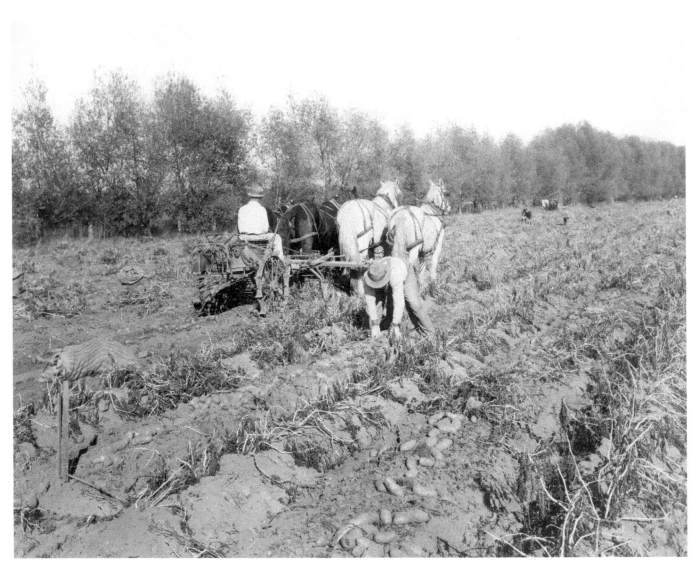

Harvesting potatoes in rural Sparks at the Cappuro farm. Italian immigrants became prominent land owners in the Reno area.

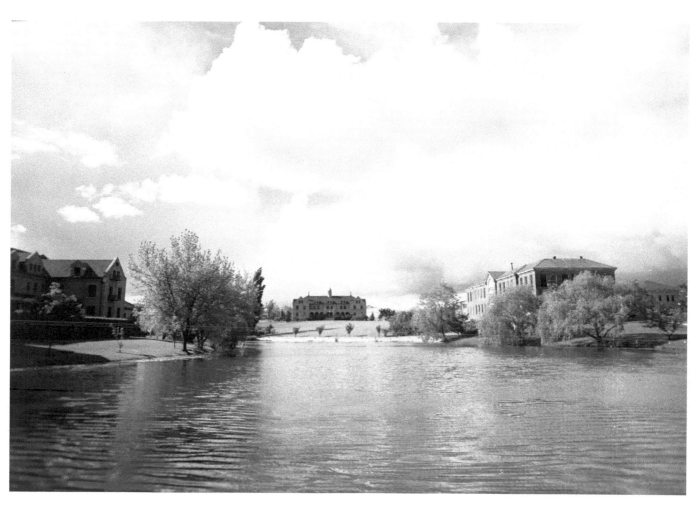

Manzanita Lake at the University of Nevada, viewed to the north.

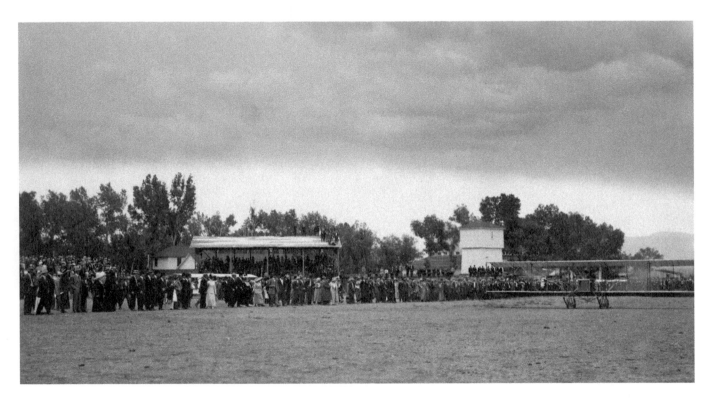

A biplane landing in a field in Reno around 1915. The city didn't have an airfield until 1920. Airmail service was implemented in 1921, and the first commercial airline began its operations in Reno in 1927.

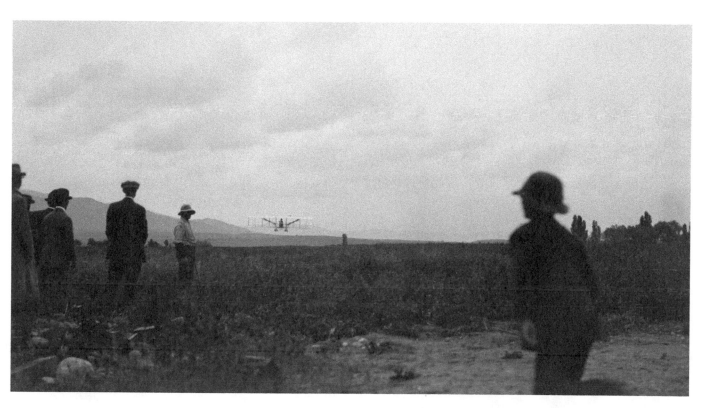

Another view of the biplane, skimming above the fields.

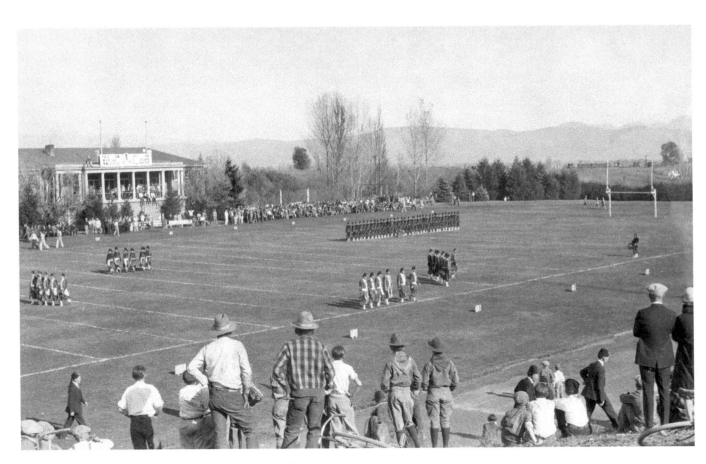

Shriners march on Mackay Field at the University of Nevada.

A parade in Reno features these World War I soldiers.

Raymond I. "Pappy" Smith, the patriarch of Reno's spectacularly successful casino Harolds Club, in his early days when he was making a living running games of chance at county fairs.

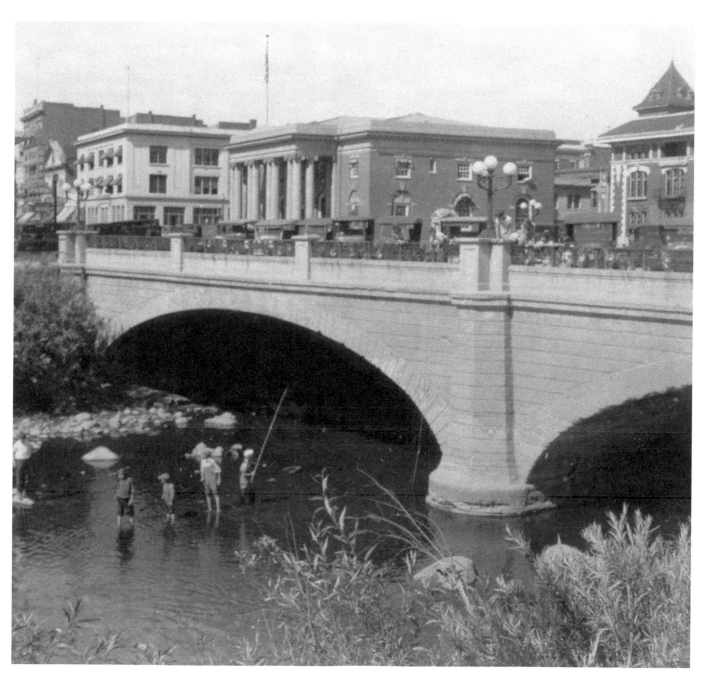

The Truckee River and Virginia Street bridge in the 1920s.

A view of the Riverside Bridge at the Booth Street under construction, with steel reinforcing rods in place, July 1920.

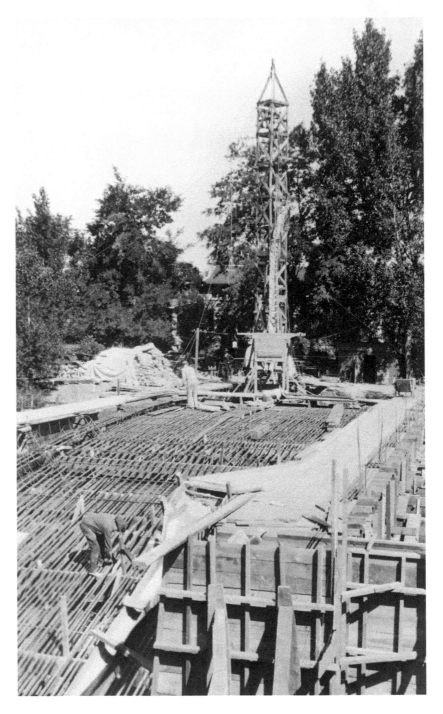

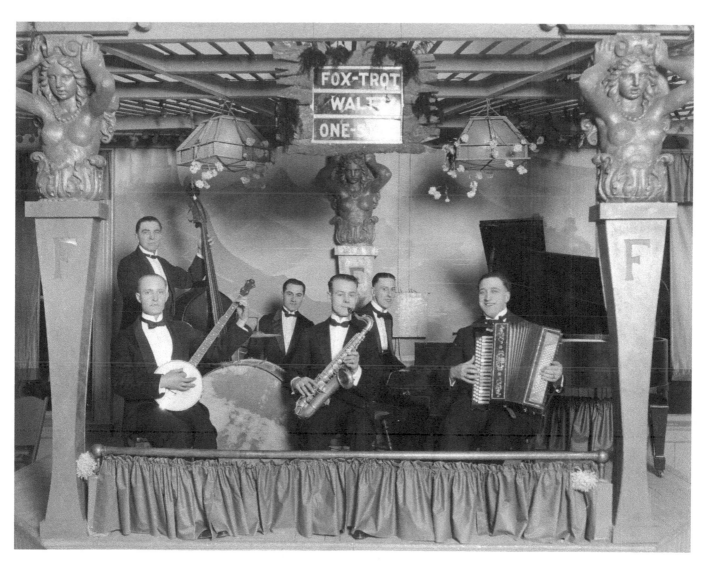

Tony Pecetti's jazz band (Tony is playing the accordion), 1920.

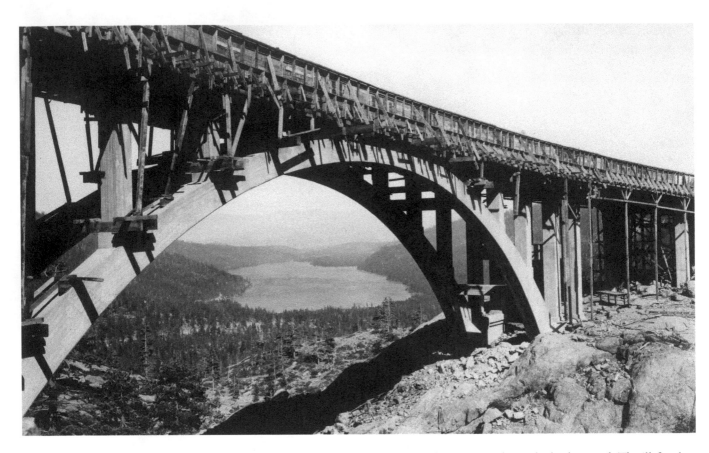

Donner Lake Memorial Bridge on Highway 40, under construction in 1925 with Donner Lake in the background. The ill-fated Donner Party blazed this route through the northern Sierra Nevada in the winter of 1846–47. Trapped by a severe winter storm, over half of them died and many resorted to cannibalism to survive.

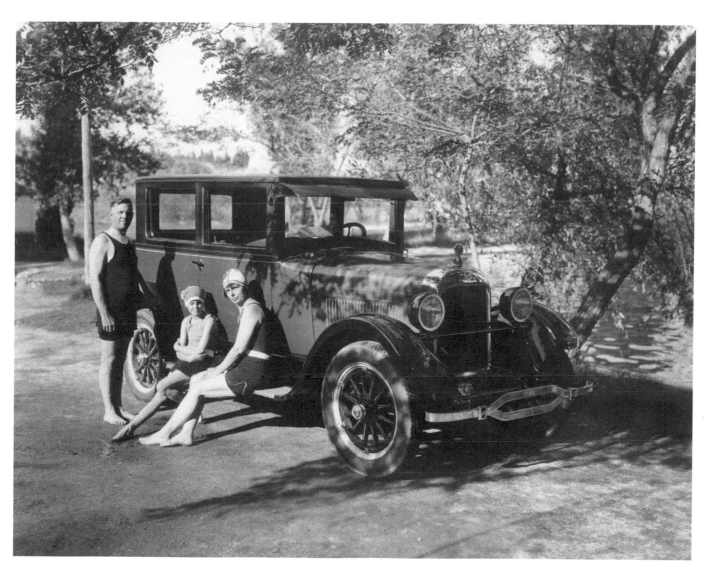

A Reno family ready for a swim in the 1920s.

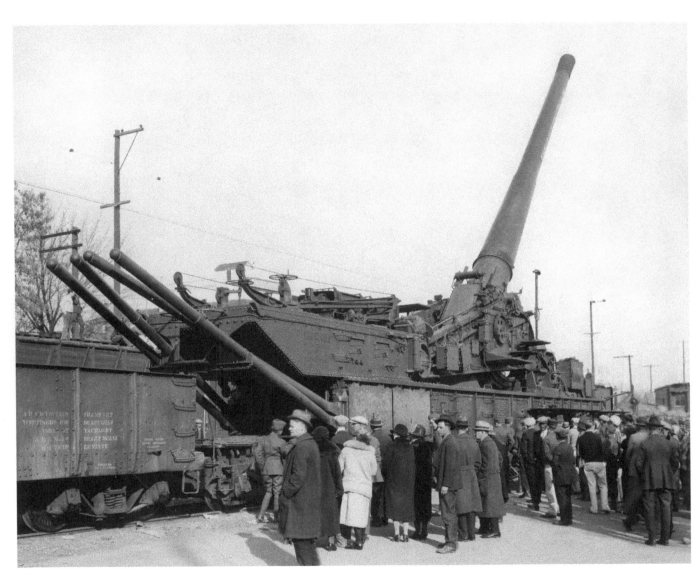

This German Big Bertha howitzer came through Reno mounted on a train car after World War I.

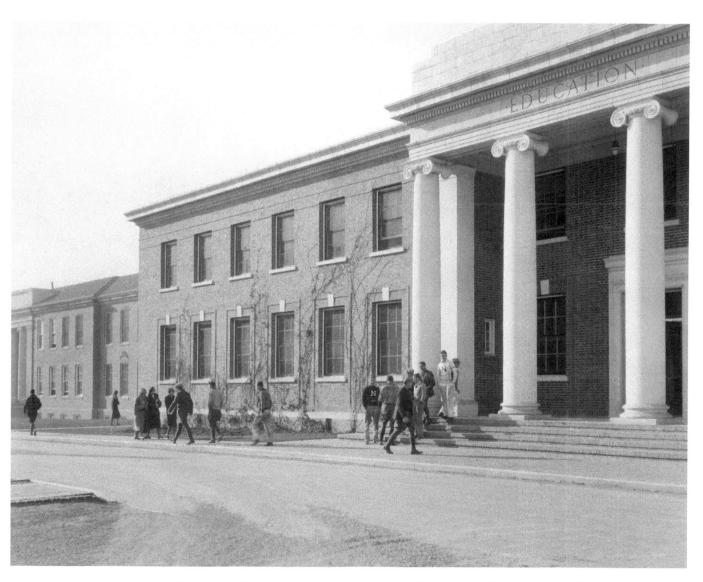

University of Nevada students outside the first Education Building (now the Thompson Building).

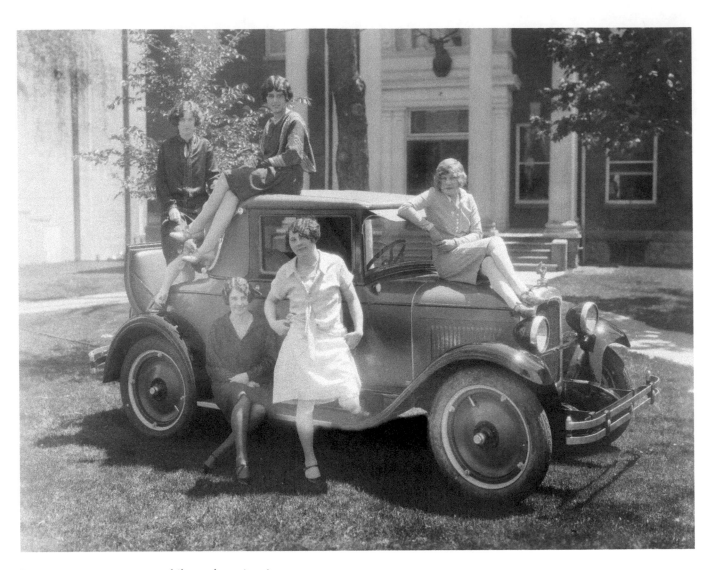

Young women on an automobile on the university campus.

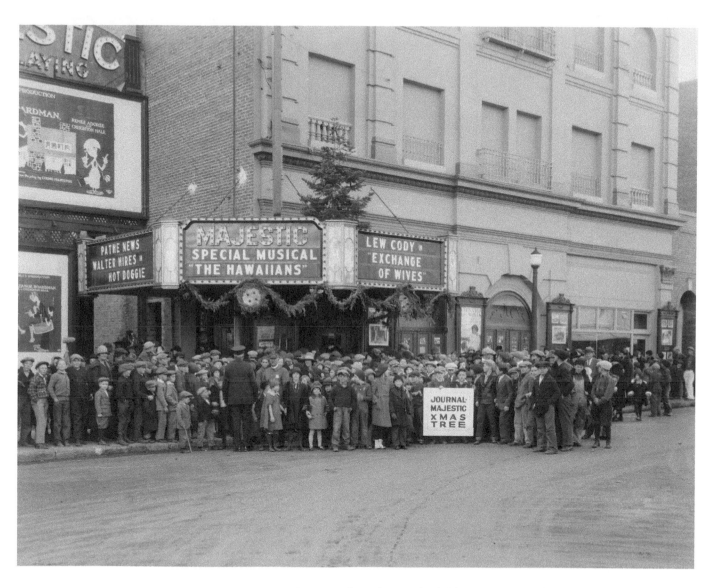

A group of people, mainly children, in front of the Majestic Theater in 1925.

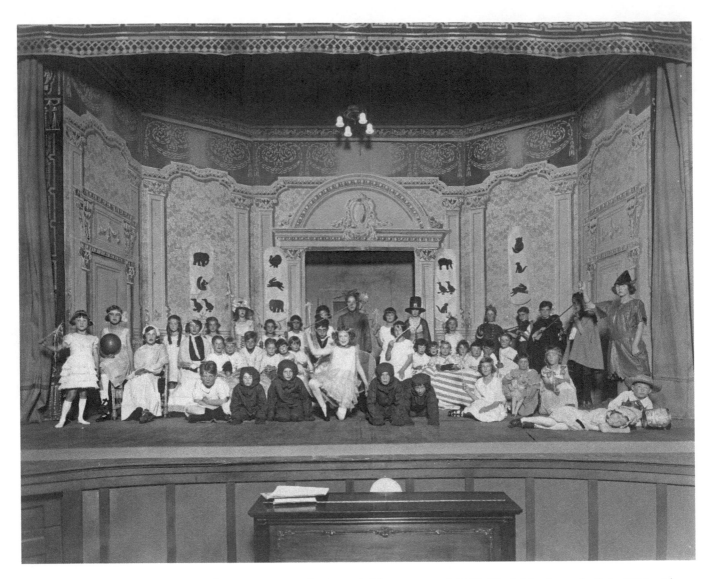

The cast of a children's play, *One Night in a Nursery,* in the Majestic Theater around 1923. The Majestic was built in 1910 with 1,216 seats, joining the Wheelman's Theater and McKissick Opera House. Later, the Granada Theater was added to the group that attracted top-name entertainers to the city. By 1920, these large theaters were featuring movies as well as live performances.

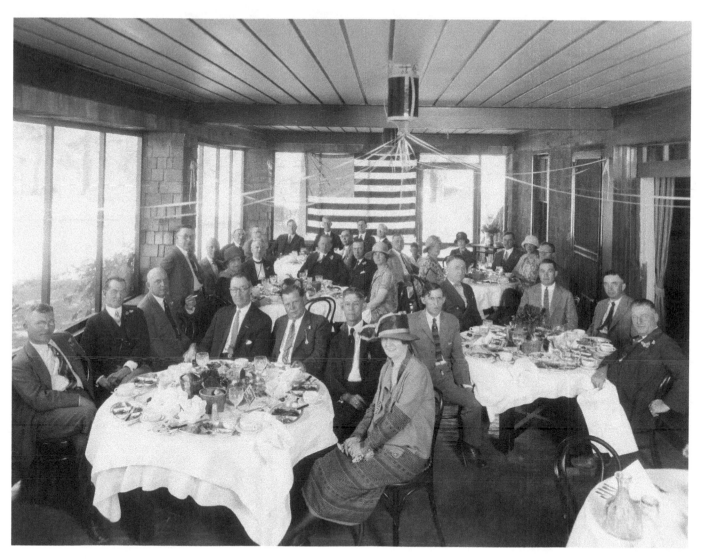

Reno Elks Club Luncheon at the Al Tahoe Inn in honor of Grand Exalted Ruler of the B.P.O.E., W. H. Atwell, in July 1925.

The Federal Outfitting
Company clothing
store on Sierra Street
was offering free bridge
lamps as a promotion
around 1928.

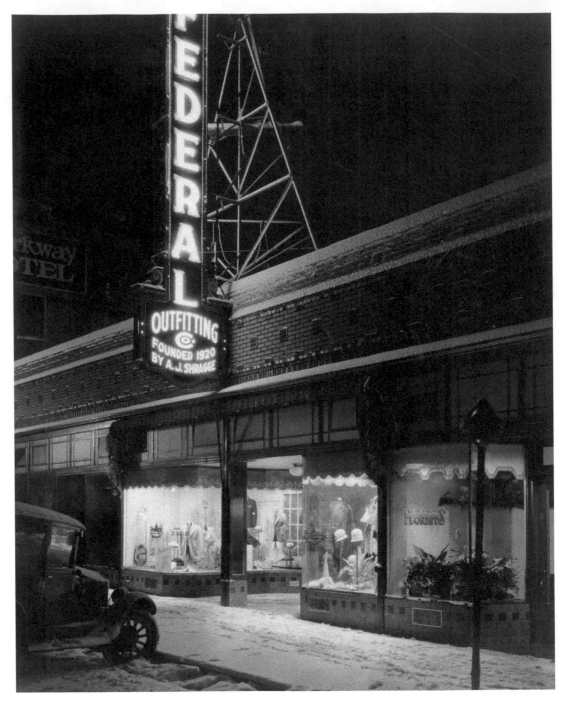

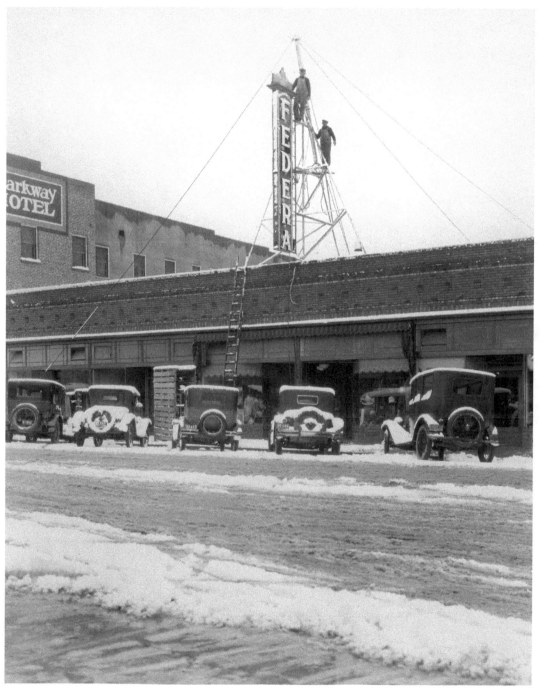

Workmen install a sign for the Federal Outfitting Company which opened in 1928.

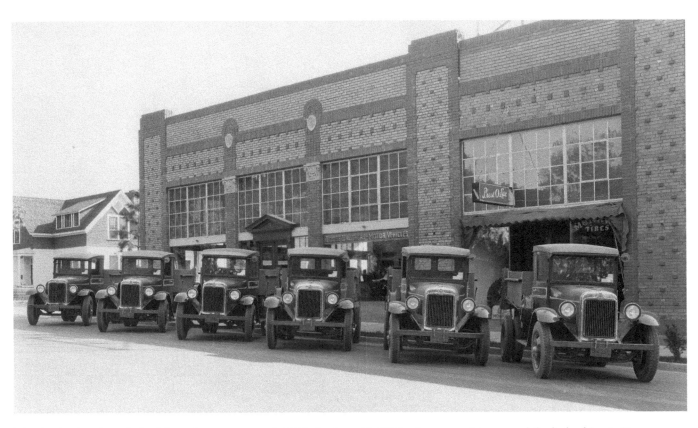

The Dodge Brothers dealership and garage, around 1927. By the mid-1920s, there were 12 automobile dealerships in Reno.

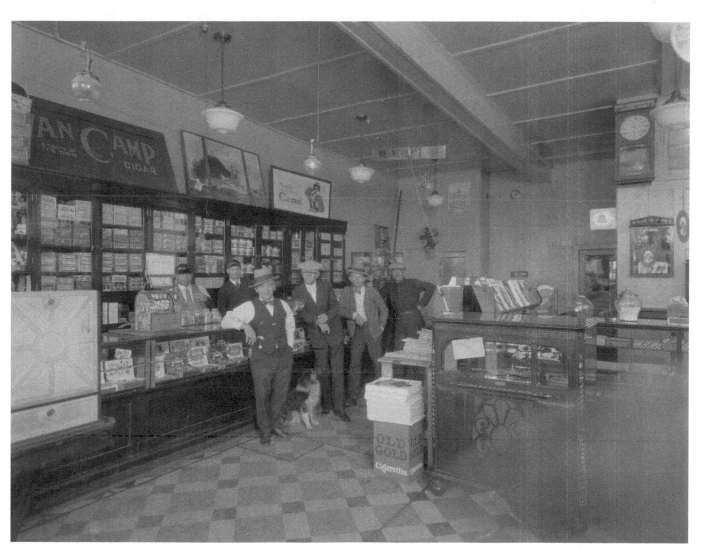

The Riverside Cigar Store in the Riverside Hotel in Reno (ca. 1927). The location of the Riverside Hotel is on the exact site of the Lake House hotel, the first building in Reno.

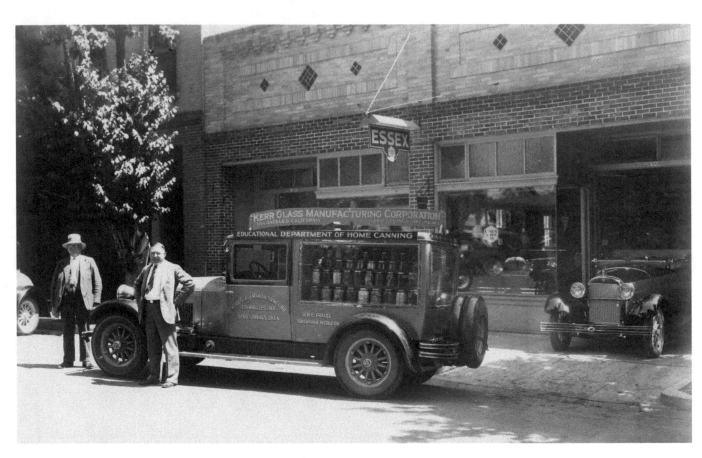

The traveling Home Canning truck of the Kerr Glass Manufacturing Corporation (ca. 1927).

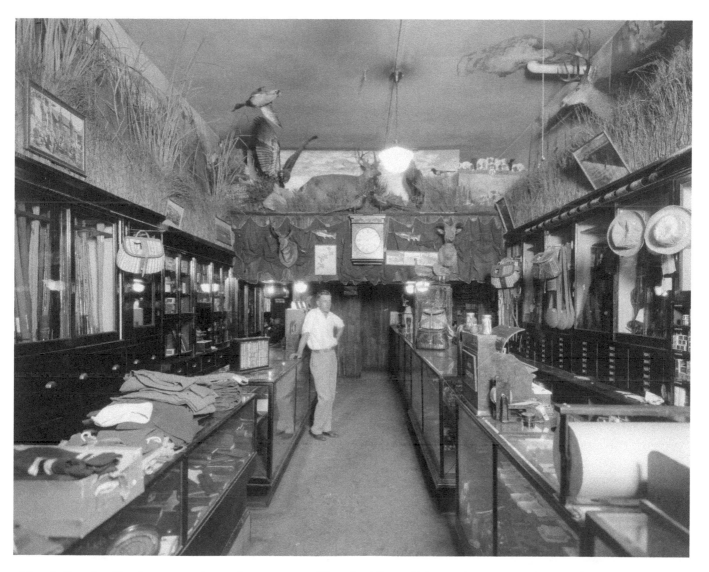

Nevada Sporting Goods store, on the northwest corner of Douglas Alley and Virginia Street, around 1927. Hunting, fishing, and outdoor recreation were always popular in the Reno area.

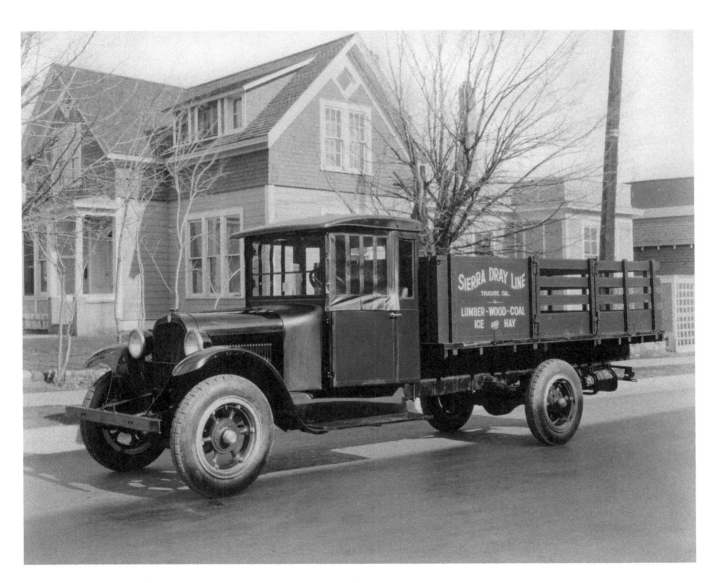

A Sierra Dray Line truck (ca. 1927).

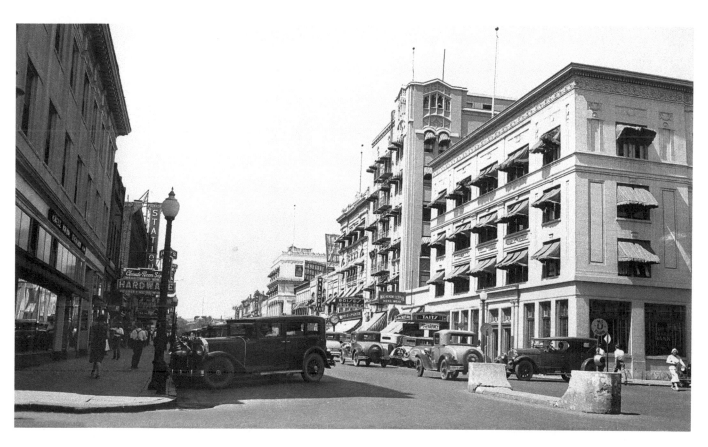

Virginia Street, viewed to the north from First Street.

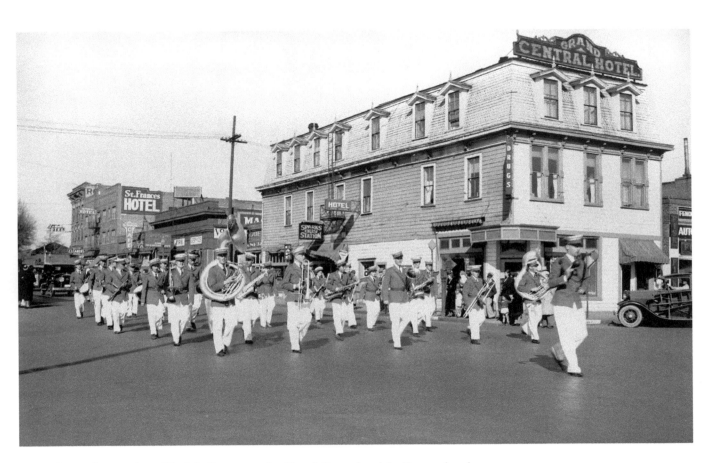

A parade marches south on Virginia Street past the Grand Central and St. Frances hotels.

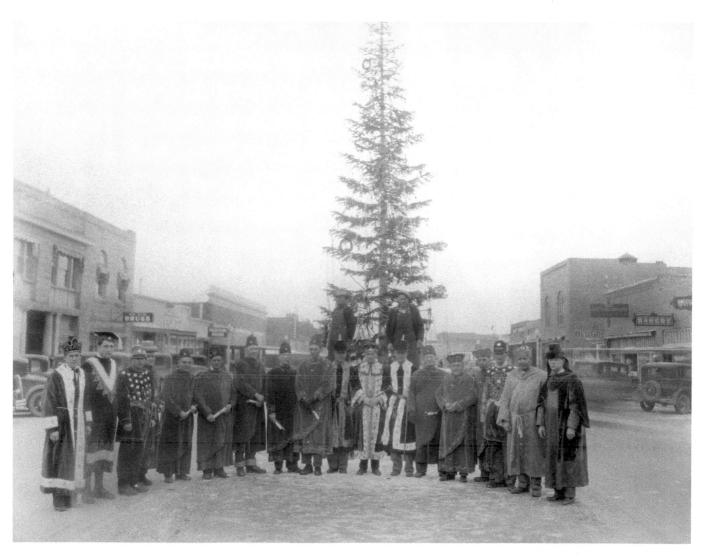

Members of the Knights of Pythias at the first Christmas tree lighting in nearby Fallon in the late 1920s. As a beneficiary of the Newlands irrigation project, Fallon supplied Reno with agricultural products, becoming especially well known for the area's Hearts O' Gold cantaloupes and for turkeys.

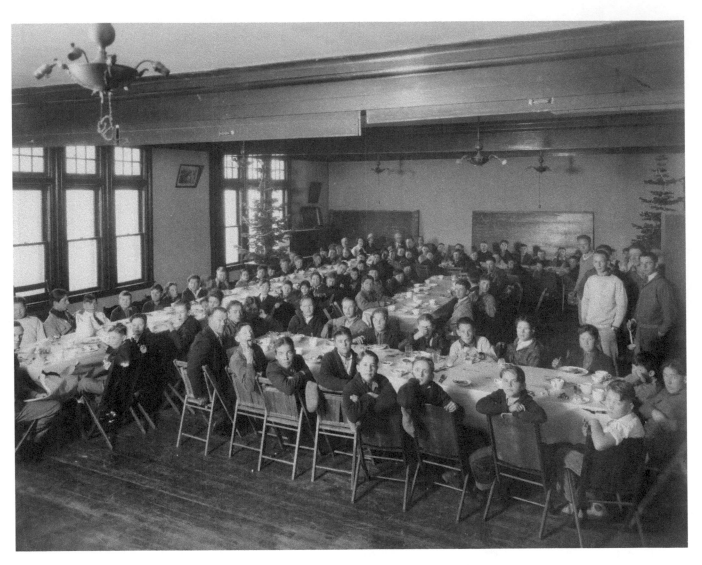

These Y.M.C.A. boys were photographed at the Century Club on West First Street at Christmastime.

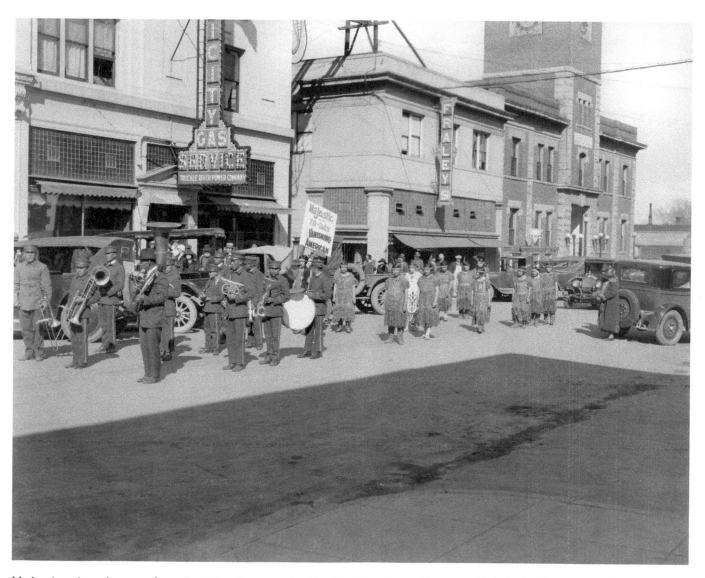

Native Americans in a parade on East First Street, passing Truckee River Power Company, Fraley's clothing store, and the Y.W.C.A. This appears to have been a promotion for the 1925 movie *The Vanishing American,* based on the novel by Zane Grey.

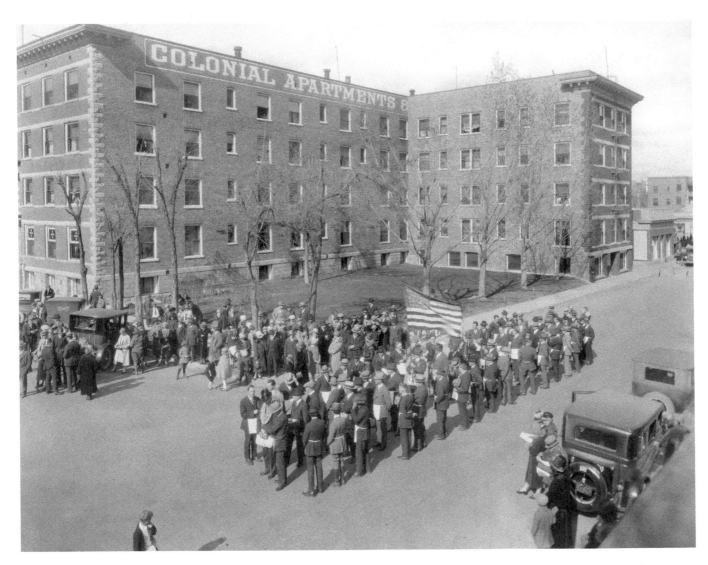

A parade in front of the Colonial Apartments (later called Ross Manor) on First and West streets in downtown Reno.

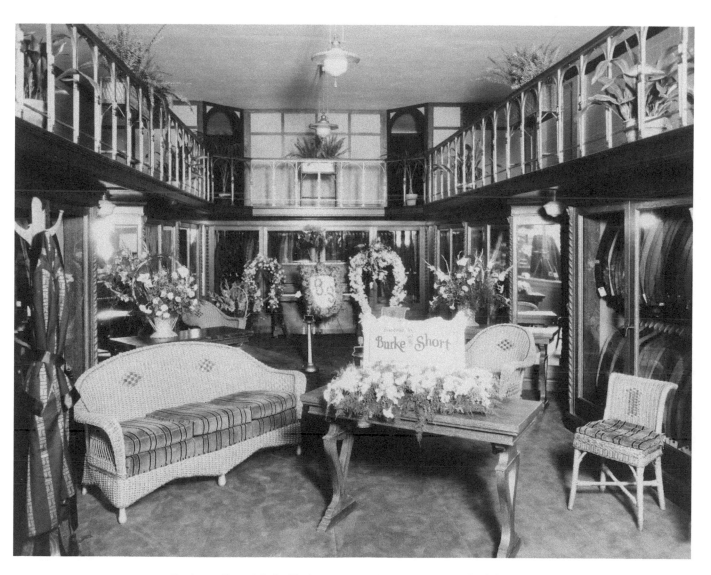

Burke & Short Men's Clothing store on Virginia Street, which later became the Herd & Short store.

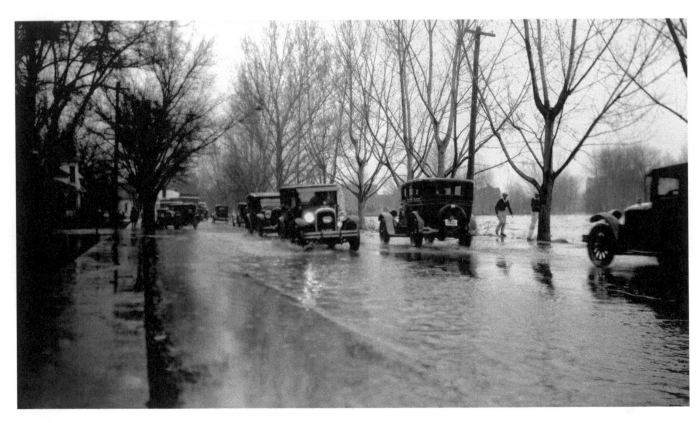

The Truckee River flooded on March 25, 1928. Boys were catching fish in the streets after attempted barricades failed to contain the water.

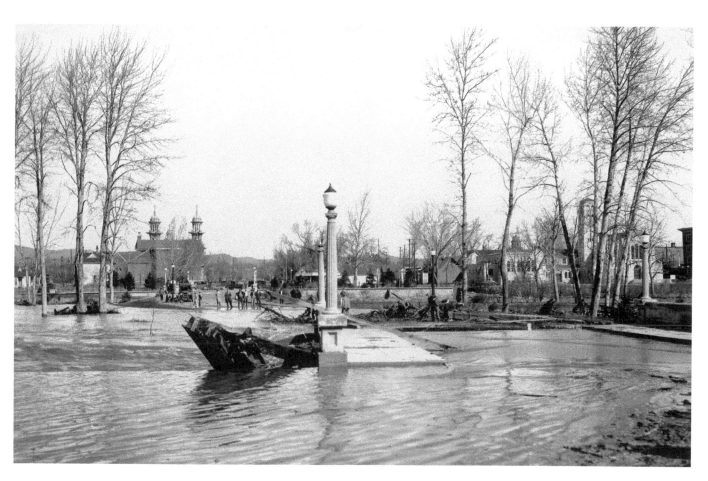

Some of the damage to Wingfield Park cause by the 1928 flood.

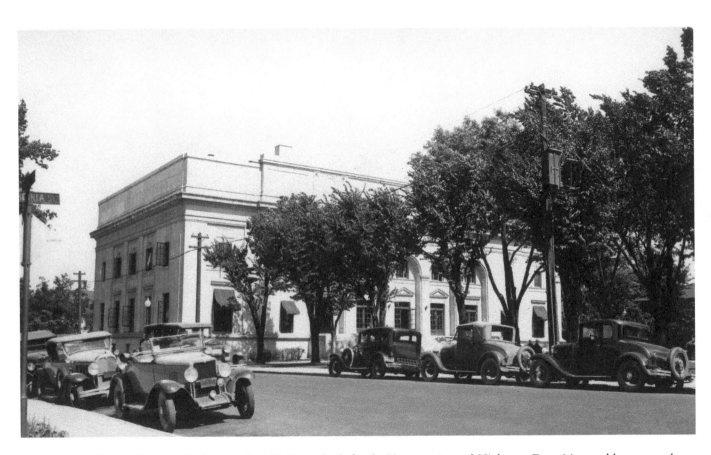

The State Building in Powning Park, around 1927. It was built for the Transcontinental Highways Exposition and later turned over to Washoe Country.

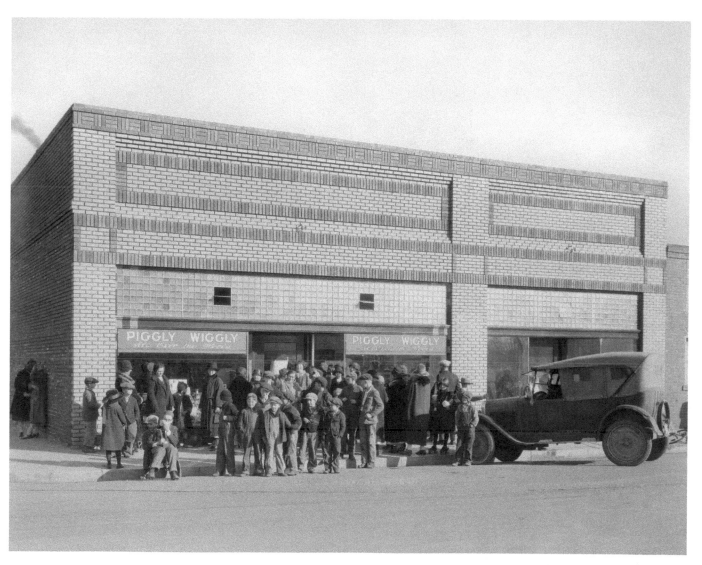

The Piggly Wiggly Grocery Store on Sierra Street in downtown Reno.

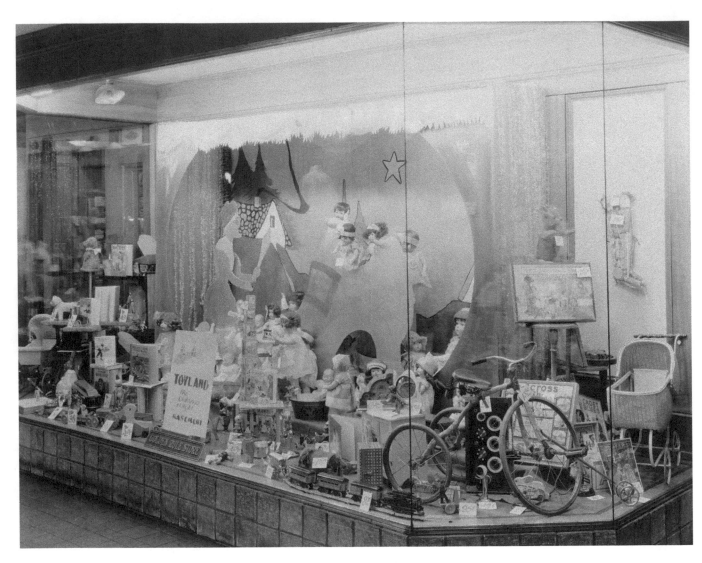

A store window of the Golden Rule Mercantile Company on Sierra Street displays toy animals for 49 cents and train set for under 9 dollars. In 1928, the shop became a J. C. Penney store.

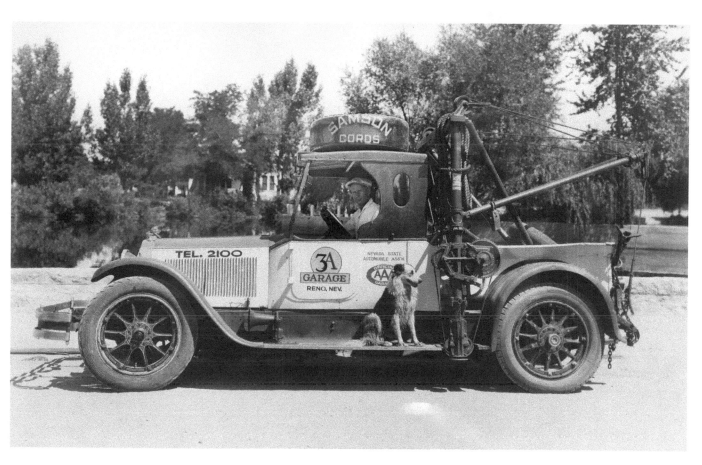

A tow truck from the 3A Garage in Reno, a distributor of Samson Cords tires.

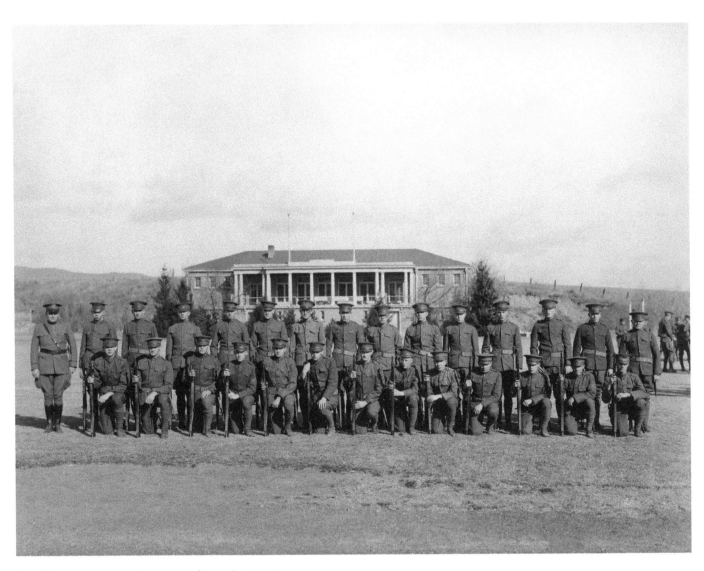

The Rifle Team at the University of Nevada, 1926.

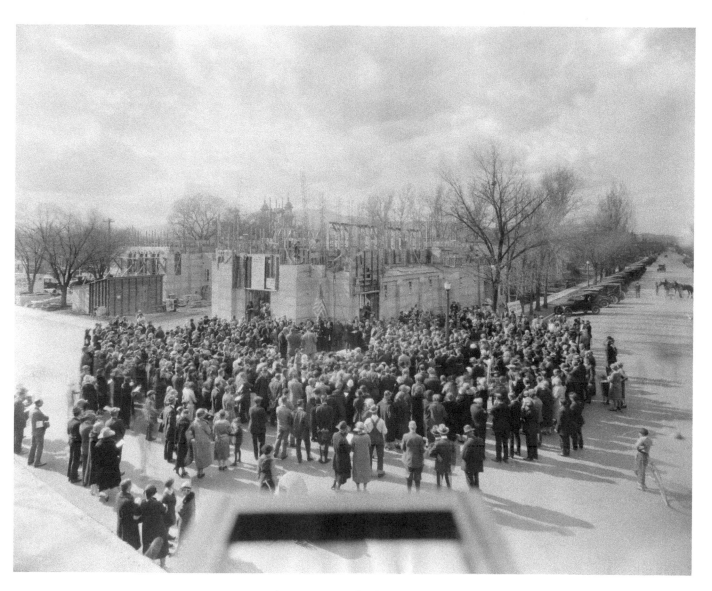

Laying the cornerstone for the First Methodist Church at First and West streets in 1926.

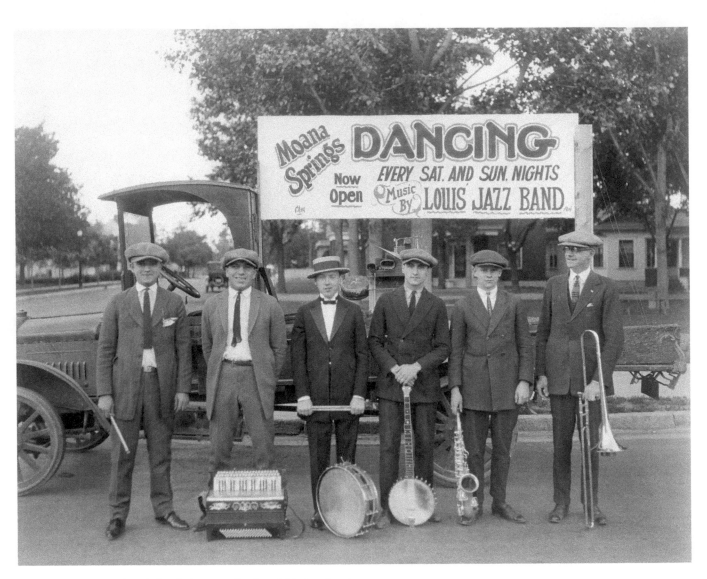

Louis Rosasco (standing behind the accordion) and his jazz band.

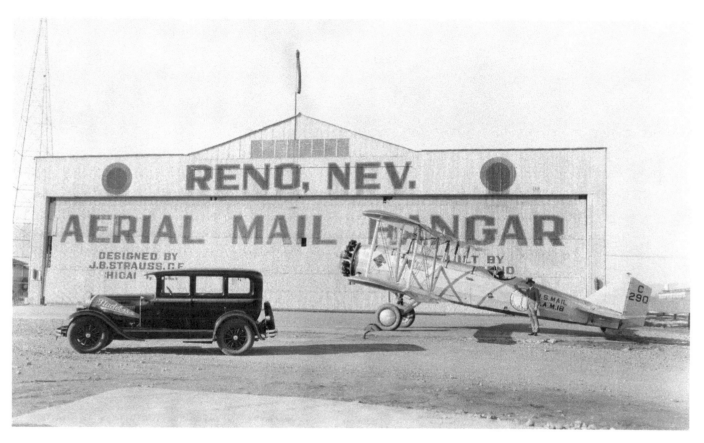

An airmail plane in front of the Reno Aerial Mail hangar at the new airfield. Mail flights landed in Reno daily.

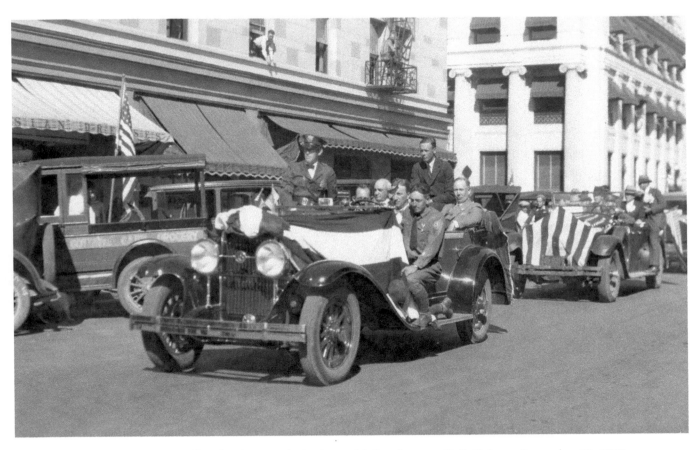

A parade honoring Charles A. Lindbergh, who is in the lead car with Reno's mayor E. E. Roberts, September 19, 1927.

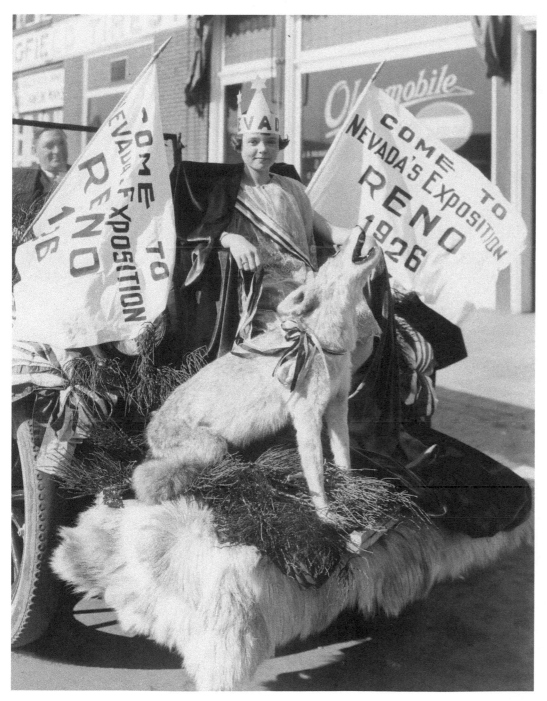

A publicity photo for the Transcontinental Highways Exposition in Reno. The exposition was planned for 1926 but was delayed until 1927.

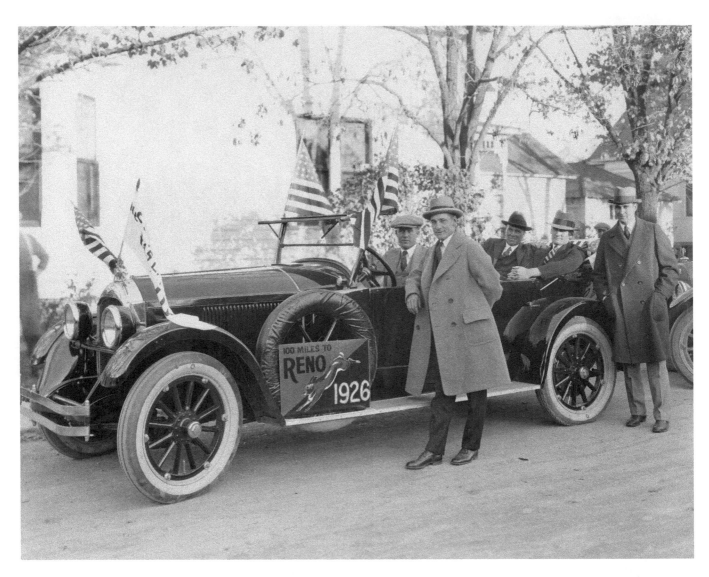

A booster delegation for the Transcontinental Highways Exposition in Reno, 1927. The exposition celebrated the completion of the Victory Highway and also the Lincoln Highway, the first coast-to-coast route. Both highways shared the same road from Wadsworth to Sacramento through Reno, which recognized the benefit of the traffic.

A publicity event on the Nevada-California state line, promoting the Transcontinental Highways Exposition. Reno had great hopes for economic gain from the event, but it was less successful than hoped and incurred a deficit in Washoe County funds that required a special tax levy.

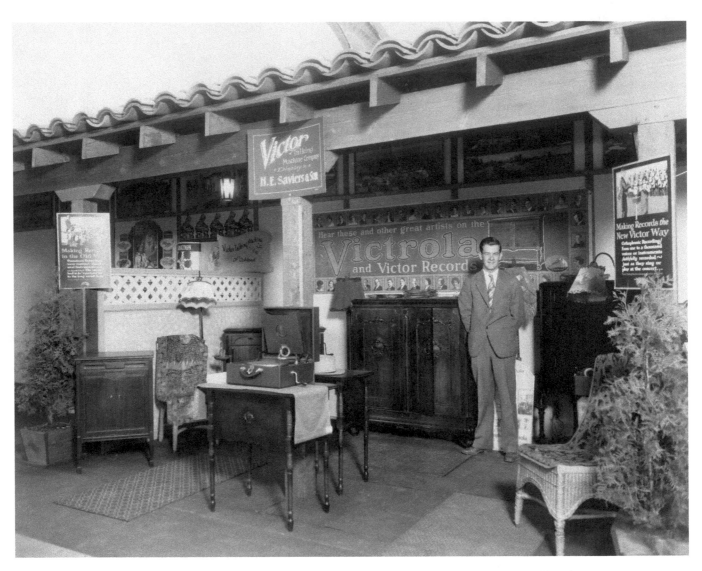

The Victor Talking Machine Company exhibit at the Transcontinental Highways Exposition at Idlewild Park in 1927 was next to a booth promotion Carnation canned milk and Fluff cake flour.

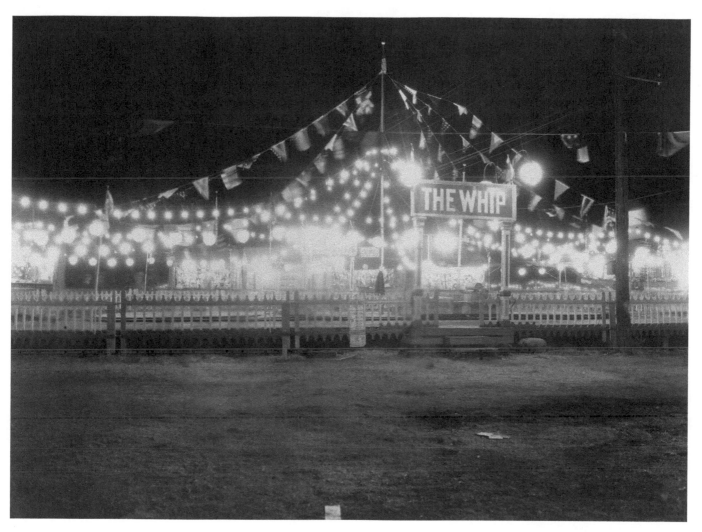

One of the carnival rides, the Whip, at the Transcontinental Highways Exposition.

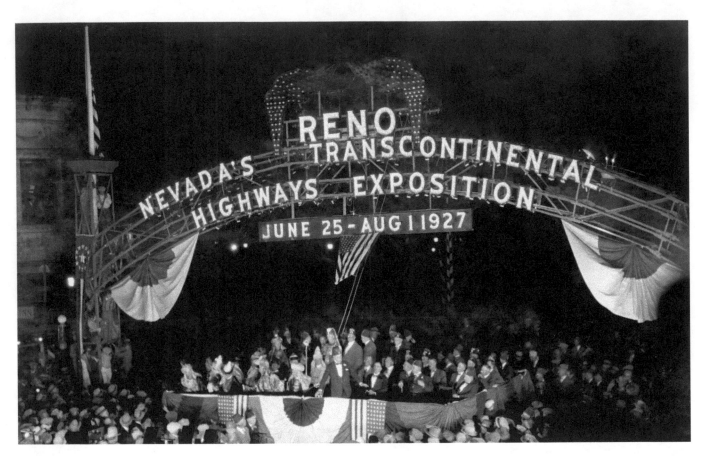

The dedication of Reno's first arch on Virginia Street, on the evening of October 23, 1926, to advertise the exposition. This arch was lit every night for ten months.

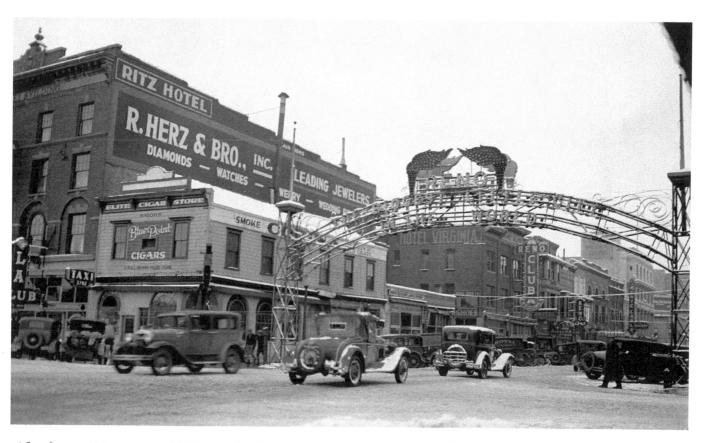

After the exposition, a prize of $100 was offered for permanent motto to be mounted on the empty arch. "The Biggest Little City in the World" was the winning entry, and the slogan is still in use on the latest arch, an enduring Reno icon.

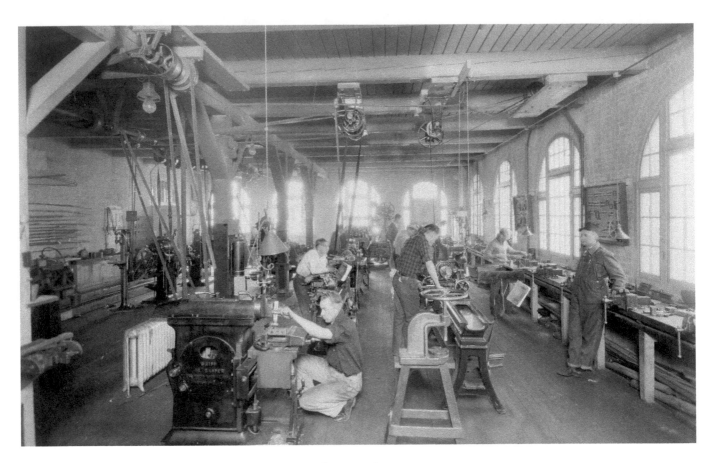

Machinists inside a Southern Pacific Railroad shop in Sparks, around 1927.

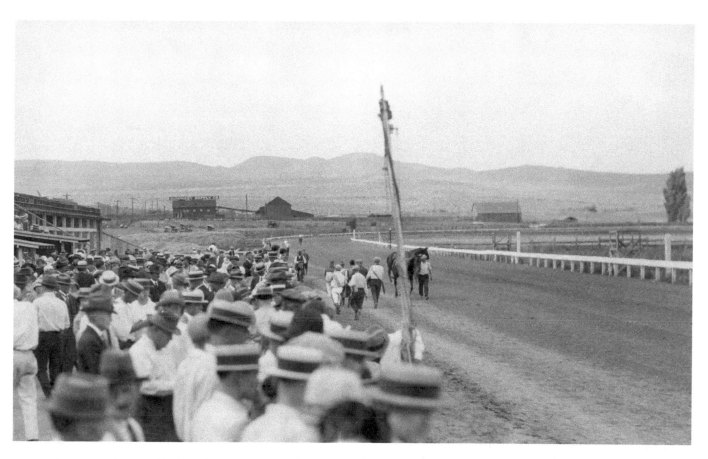

The racetrack at the Washoe County Fairgrounds in Reno. The Humphrey Supply Company Building in the background, a meatpacking plant, was designed by Frederic DeLongchamps.

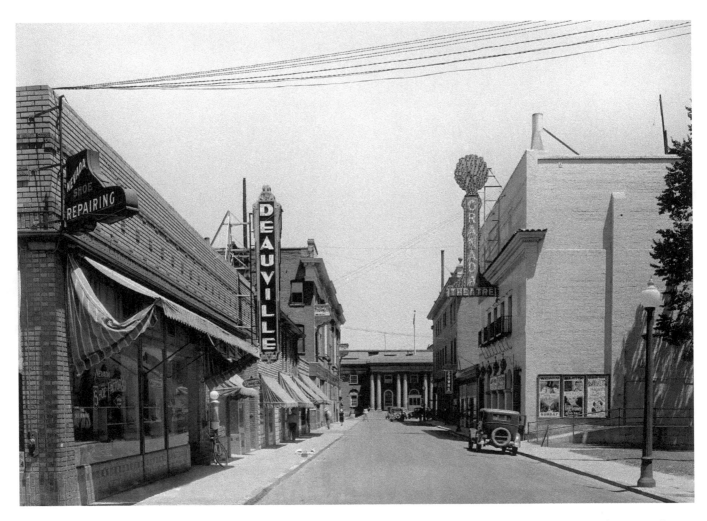

This view to the east on First Street shows the elegant Deauville Casino Cabaret at the corner of First and West. The Deauville was open for only a few months in 1931 before its owners declared bankruptcy.

New Approaches to Economic Development

(1930–1949)

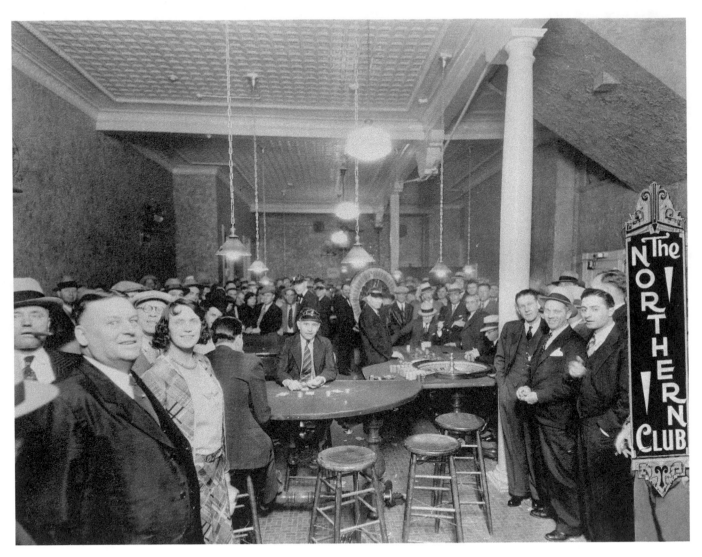

Interior of the Northern Club casino in the Commercial Hotel on Center Street. Gambling was legalized in Nevada in 1931, and in 1933 the Northern Club was licensed for ten table games and three slot machines.

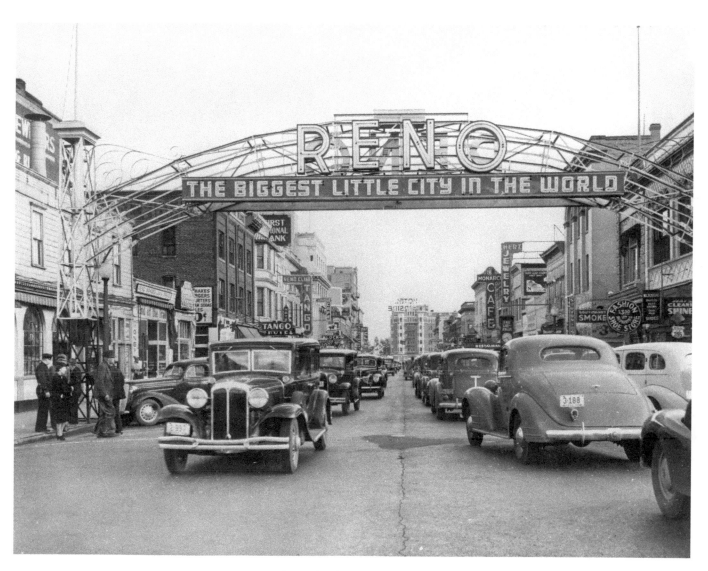

The updated Reno arch on Virginia Street. Neon was added to the sign in 1934.

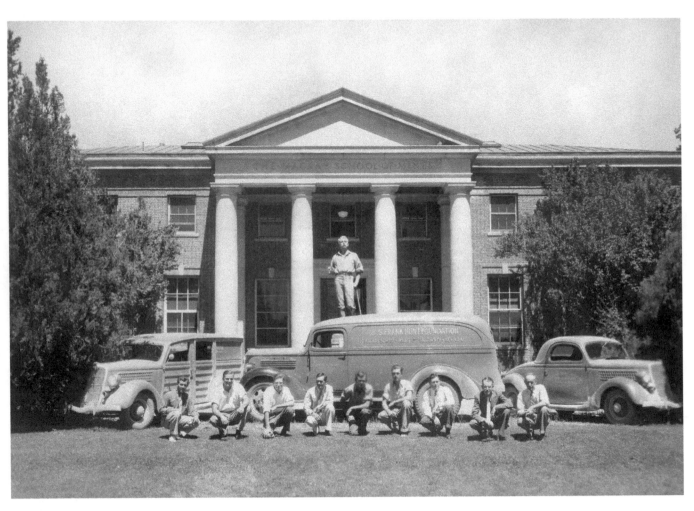

University of Nevada, Reno students and faculty on the lawn in front of the Mackay School of Mines prior to a field expedition.

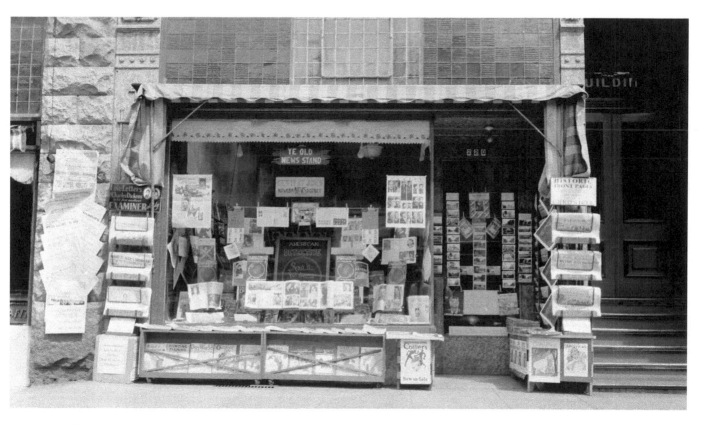

"Ye Old News Stand" in downtown Reno was displaying wanted posters and newspaper stories as part of a promotion for its selection of detective magazines when this photo was snapped.

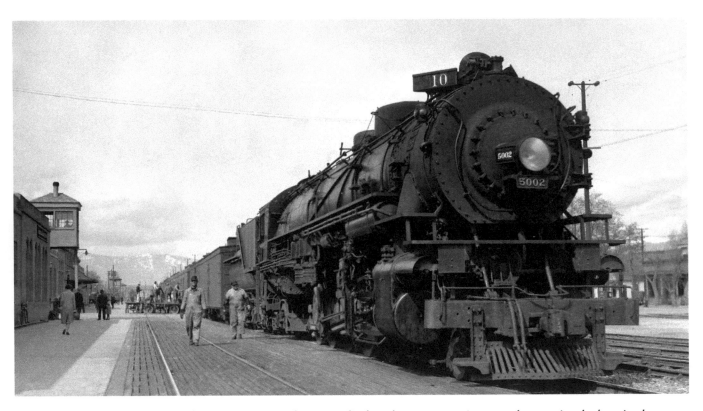

A Southern Pacific locomotive at the Reno station in the 1930s displays the enormous size steam locomotives had attained over the decades.

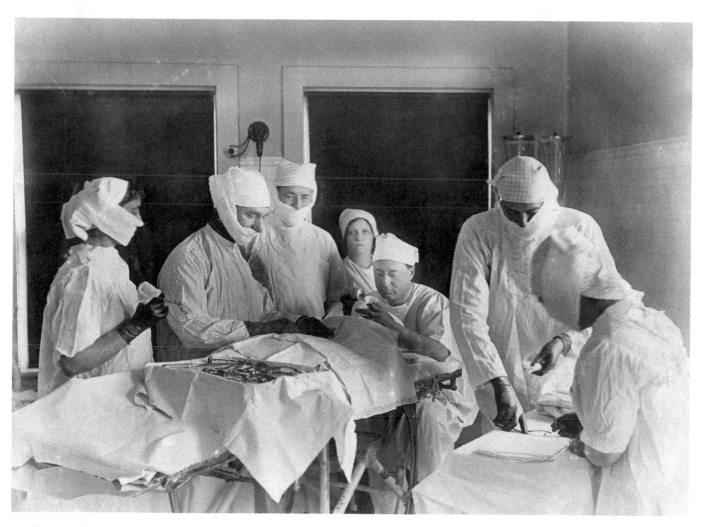

An operating room in St. Mary's Hospital in the 1930s. The hospital was established by Dominican sisters in 1908. The nurses' training school established in St. Mary's in 1910 was incorporated into the nursing program at the University of Nevada in 1959.

Douglas Alley in downtown Reno. Casinos and clubs were packed tightly into the central "red zone," inside boundaries drawn in red on the map of Reno and strictly maintained by city officials for more than two decades.

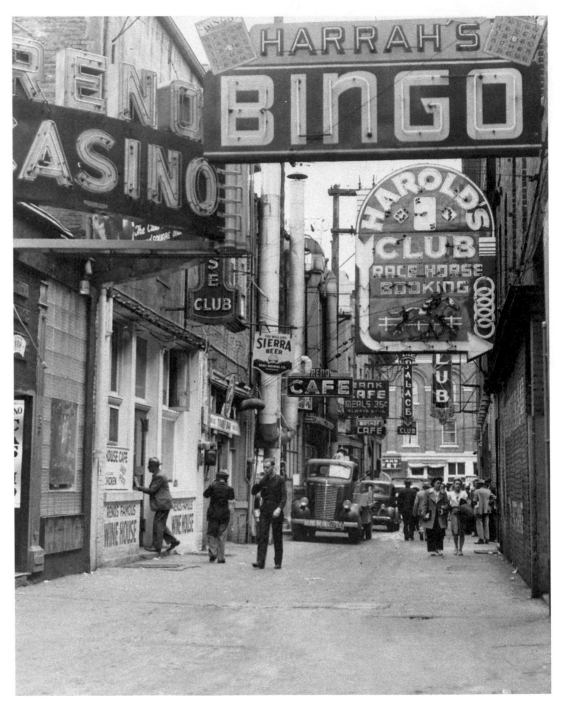

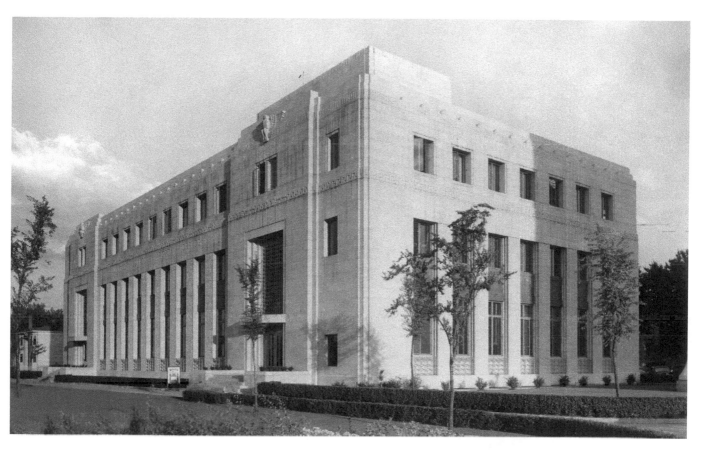

The Reno Post Office, designed by Frederic DeLongchamps in the zigzag moderne style. The building opened in 1934 and is still in use.

A skier from the
University of Nevada
ski team at Mt. Rose
(ca. 1937).

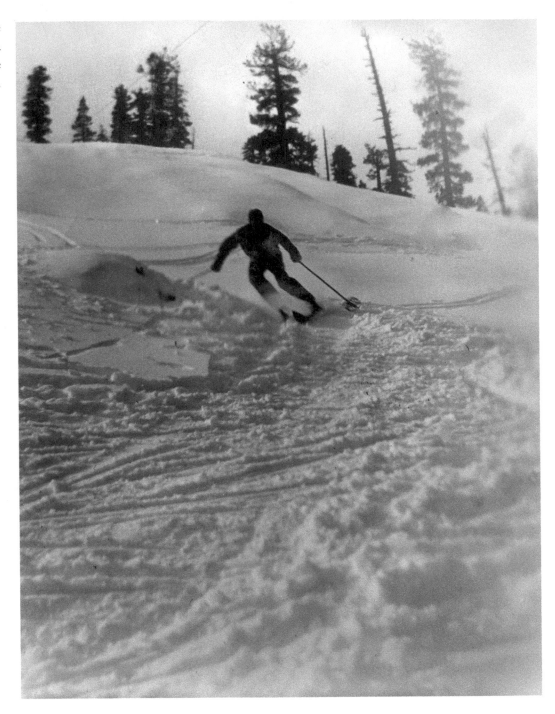

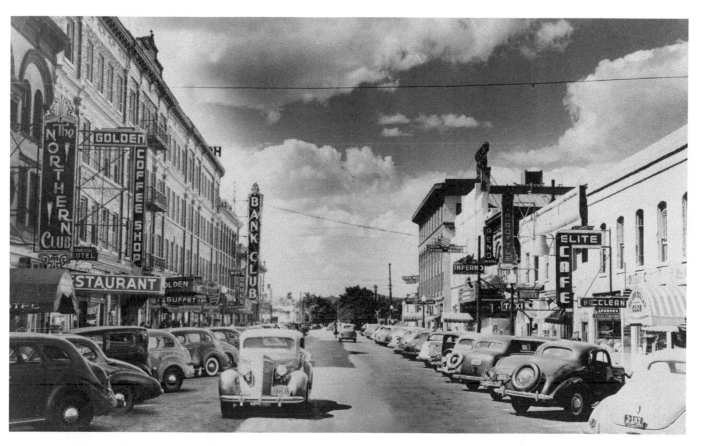

Center Street, inside Reno's red zone, was packed with passenger cars, but a taxi stand and the Pacific Stage Greyhound bus depot (right) offered additional transport for out-of-towners.

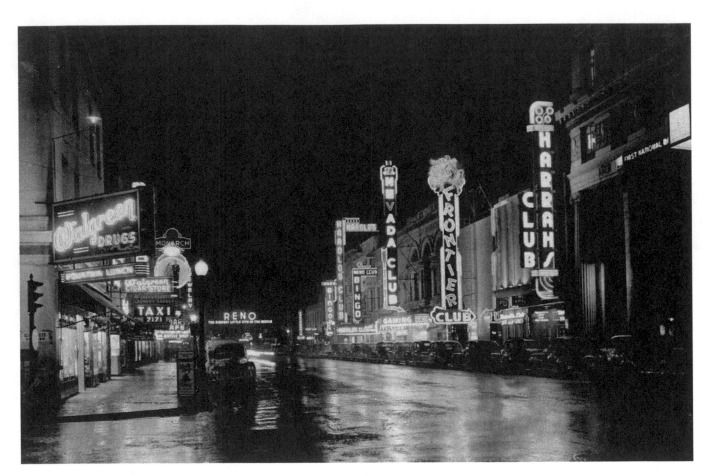

North Virginia Street at night, around 1940.

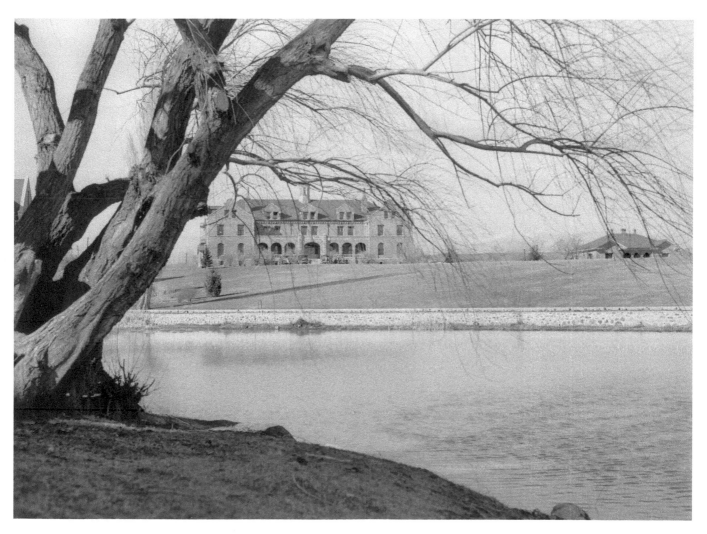

Manzanita Lake and Manzanita Hall at the University of Nevada, Reno, 1940.

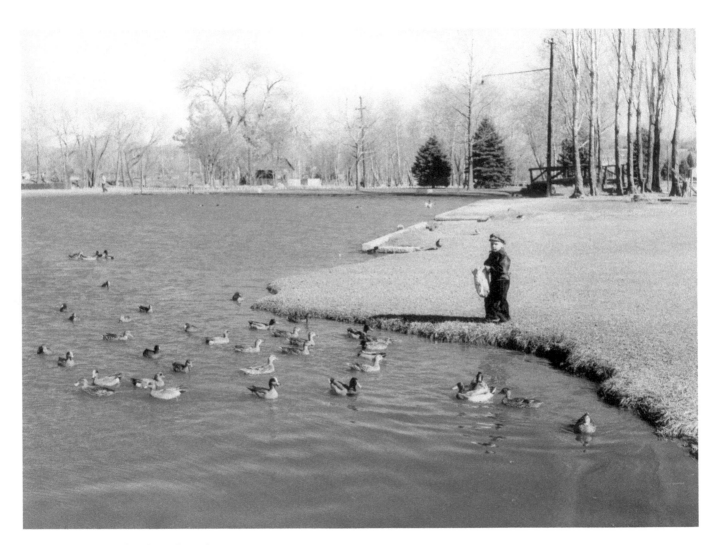

Feeding ducks in Idlewild Park, 1940.

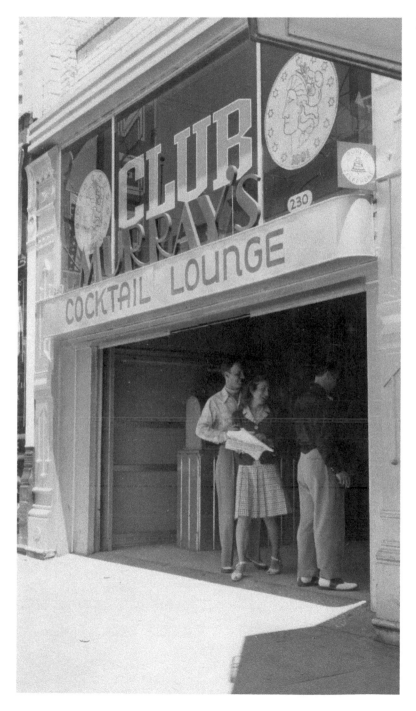

Murray's Cocktail Lounge in the 1940s.

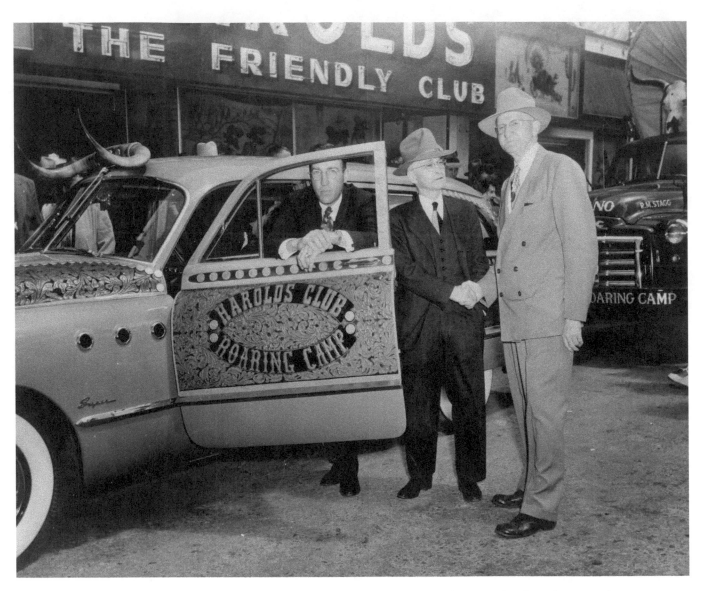

Harold Smith and Raymond I. "Pappy" Smith, the proprietors of Harolds Club, with George Southworth, a Reno businessman and politician, in front of the casino.

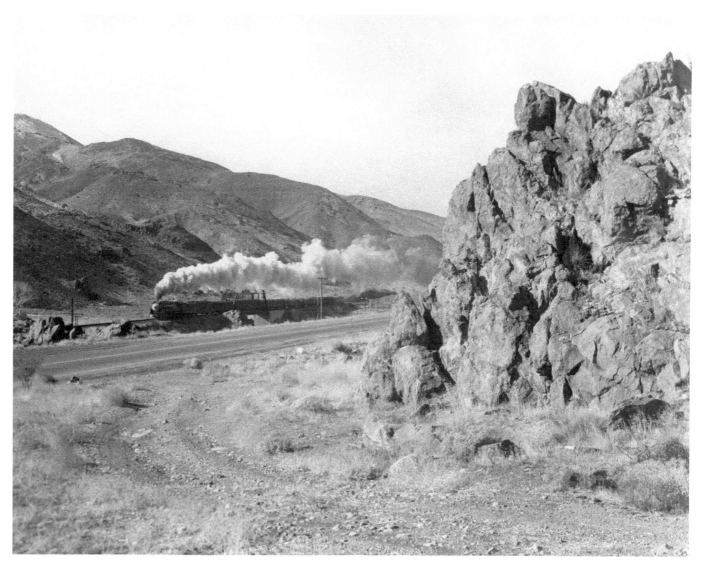

A Southern Pacific passenger train outside Reno in 1944.

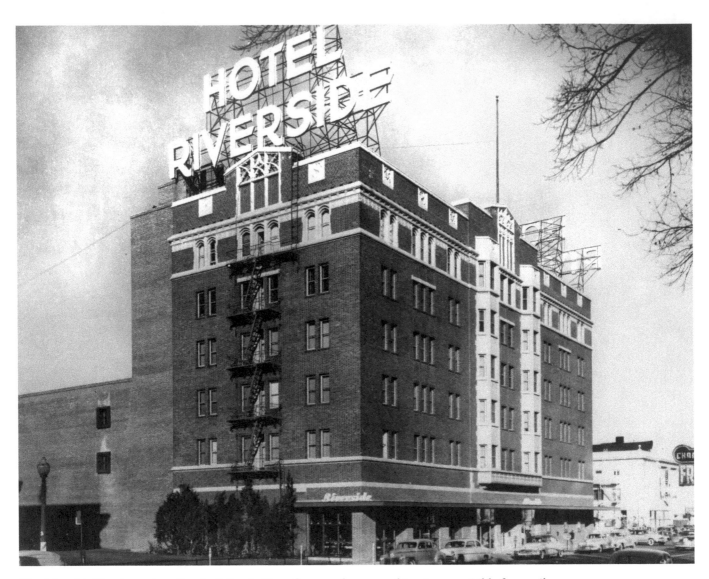

The Riverside Hotel was the tallest building in Reno for several years, and its sign was visible from miles away.

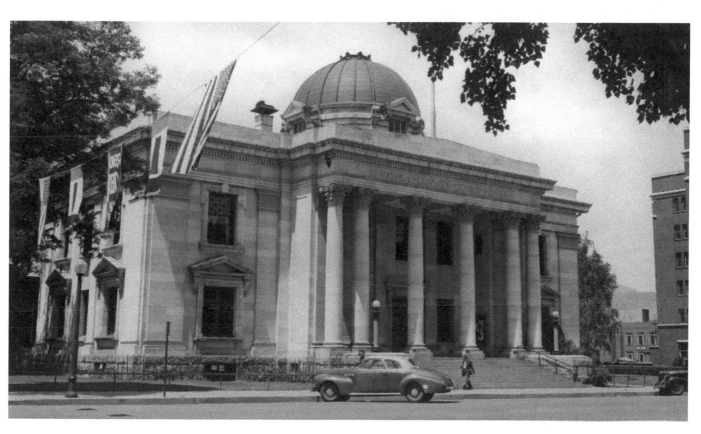

The Washoe County Courthouse.

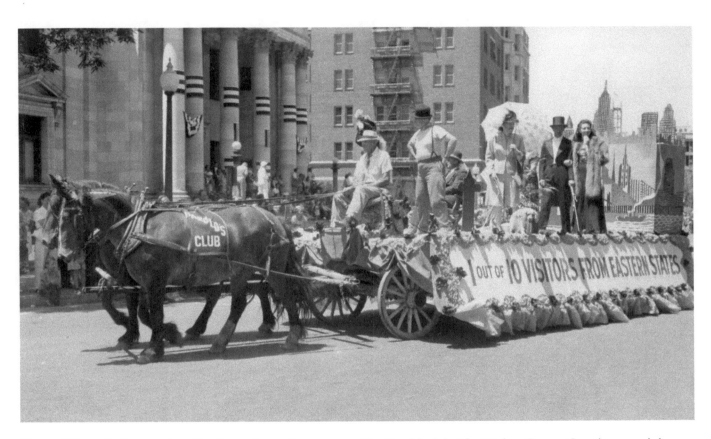

The 1946 Reno Rodeo parade, with a horse-drawn float sponsored by Harolds club. The Washoe County Courthouse and the Riverside Hotel are in the background. An active "Harolds Club or Bust" international marketing campaign seemed to have worked. It was the largest casino in the world for 15 years. Howard Hughes bought it in the 1970, after a period of decline.

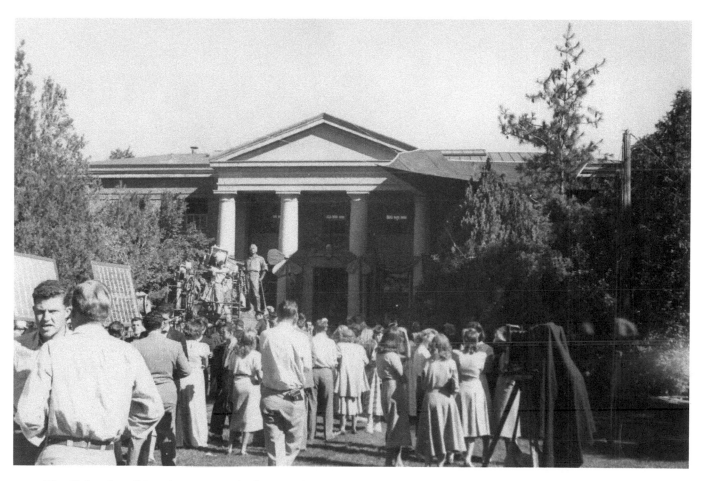

The University of Nevada was a popular location for shooting college movies in the late 1940s, due to the Ive League look of the campus and its proximity to California. This scene is from the filming of *Mother Is a Freshman,* a 1949 movie staring Loretta Young, Van Johnson, and Rudy Vallee.

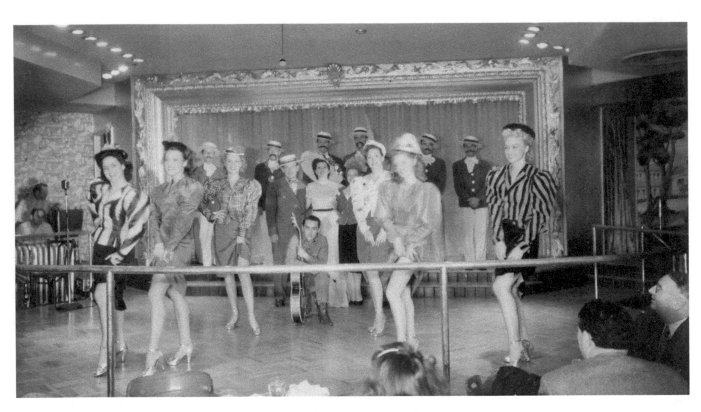

The Gay Nineties Review, a stage show in the Golden Hotel and Casino in 1948.

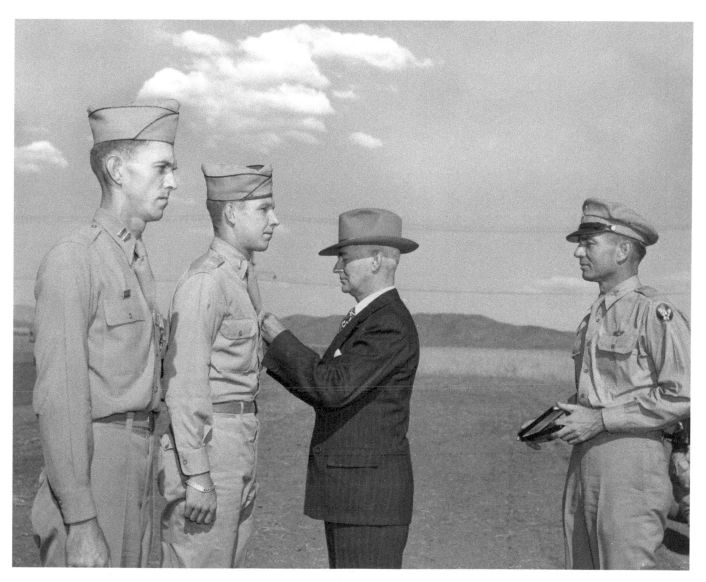

Governor Vail Pittman with members of the 565th Army Air Force Base Unit, 3rd Operational Training Unit, Ferrying Division, ATC, Reno Army Air Base (later the Stead Air Base) in 1948.

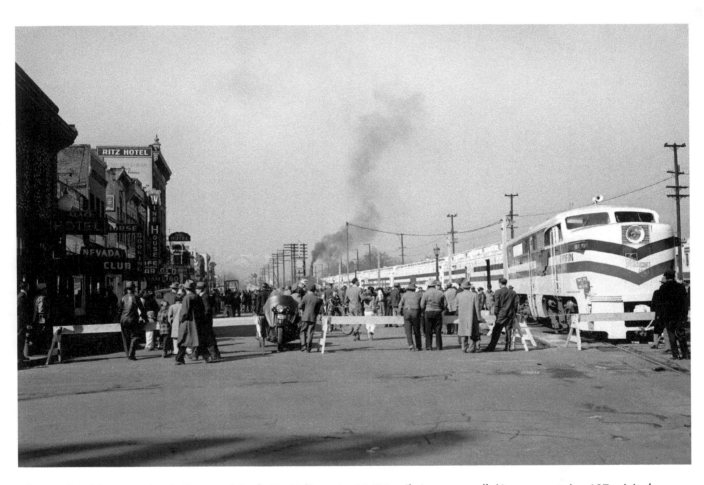

The Freedom Train stopping in Reno on March 22, 1948, on its 33,000-mile journey to all 48 states, carrying 127 original manuscripts documenting U.S. history.

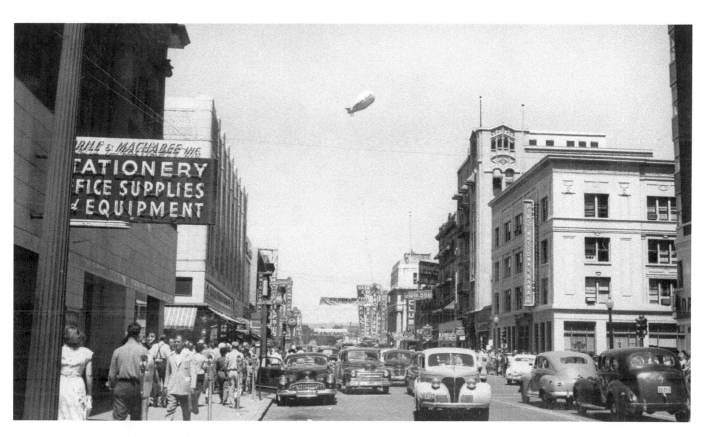

This north-facing view of Virginia Street shows a tethered blimp promoting Harolds Club and a banner for a Policeman's Ball (c. 1949).

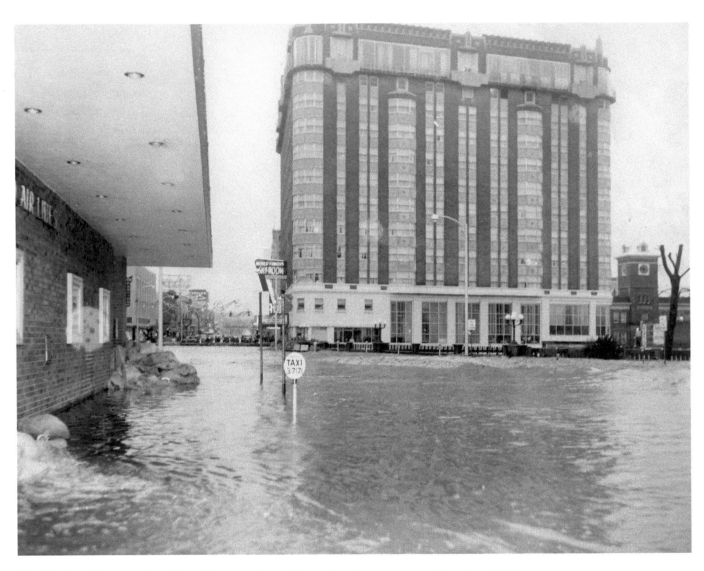

The Truckee River inundated Island Avenue, along with much of downtown, in November 1950.

Growing and Thriving

(1950–1970s)

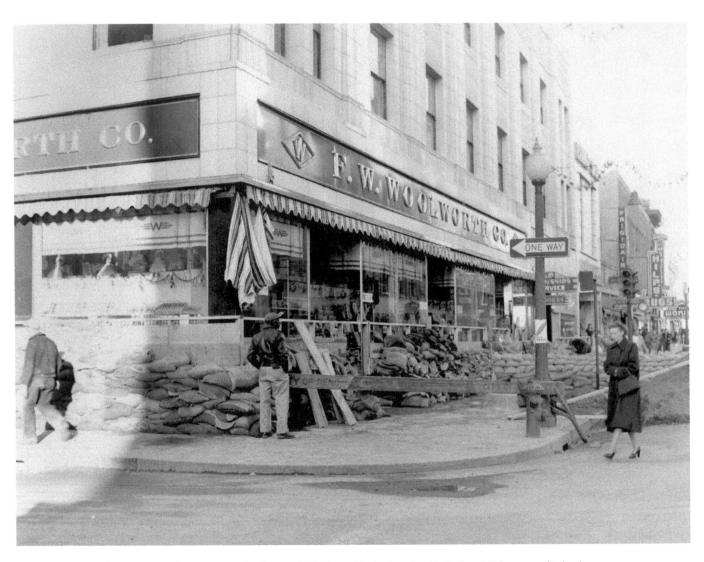

Sandbags at North Virginia and First streets in front of Woolworth's during the 1950 flood. There was little chance to prepare as the water rose quickly above the banks of the Truckee after four days of rain.

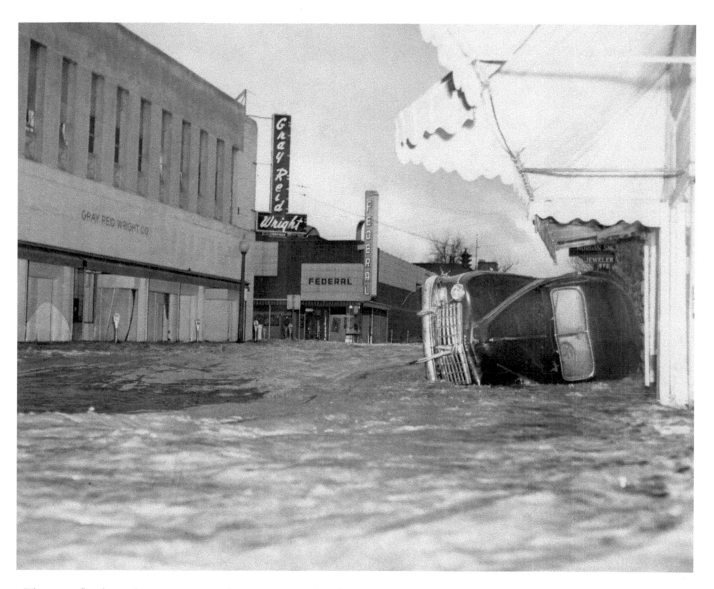

The 1950 flood was the worst on record, causing more than $6,000,000 of damage to downtown businesses. Hundreds of people helped move merchandise out of stores such as the Gray Reid Wright department store and Federal Outfitters. Automobiles were no match for the rushing water in the streets.

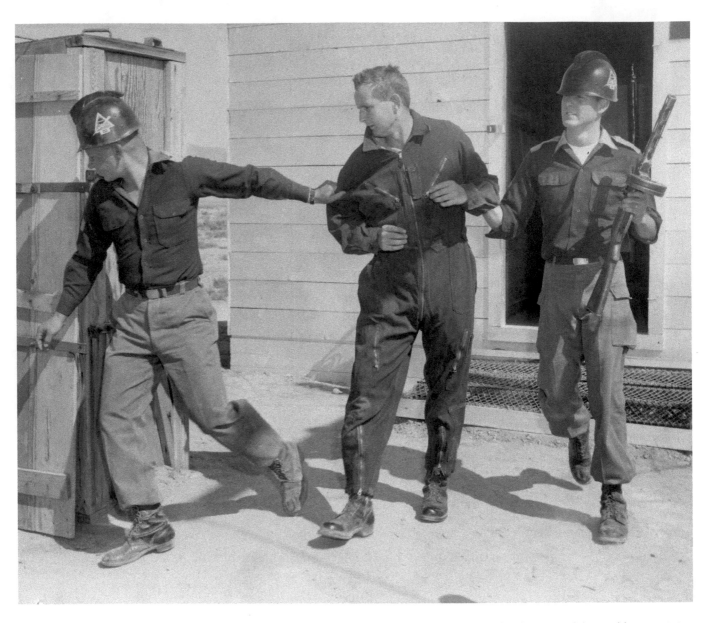

In 1955, airmen such as this one were confined in small boxes at the counter-brainwashing school as part of their cold war training at Stead Air Force Base. The base as established in Reno in 1942 to train signal companies for the war. It was given to the City of Reno in 1966, and then sold to Bill Lear in 1968. He worked on an unsuccessful low-pollution, steam-powered engine project.

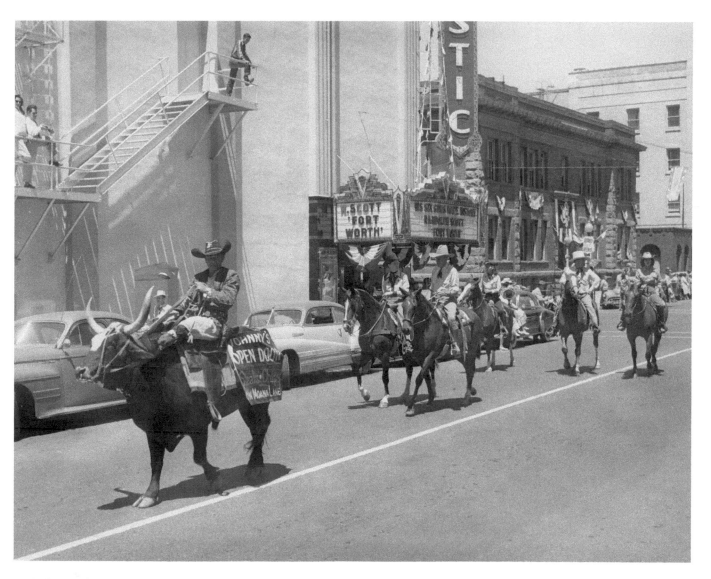

Riders in the 1951 Fourth of July rodeo parade pass the Majestic Theater, which was showing a Western, appropriately enough. All Reno citizens were expected to wear Western attire during the rodeo week.

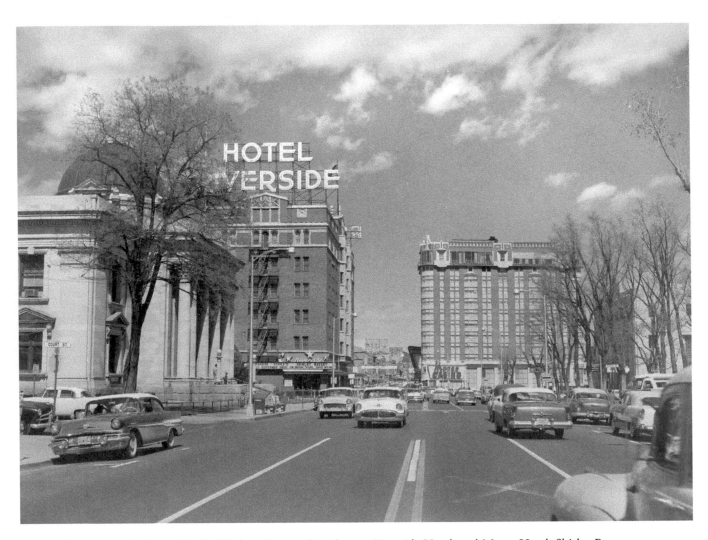

Virginia Street near the river, with the Washoe County Courthouse, Riverside Hotel, and Mapes Hotel. Shirley Bassey, headlining at the Riverside, had her first hit in 1957 with *Banana Boat Song*. She would later record the theme songs for three James Bond movies.

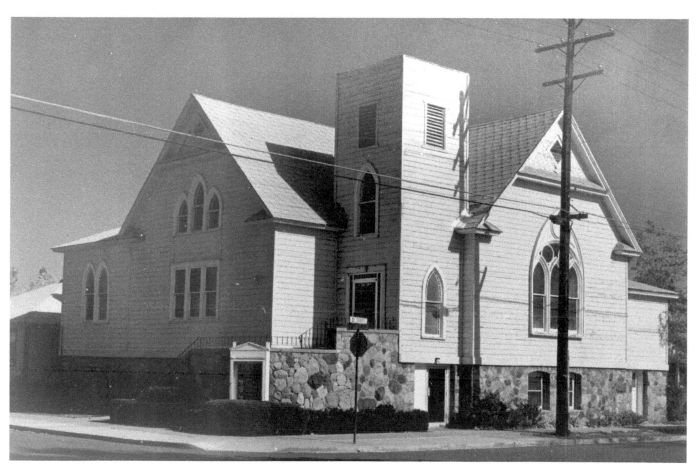

The New Hope Covenant Church in Sparks in the 1950s.

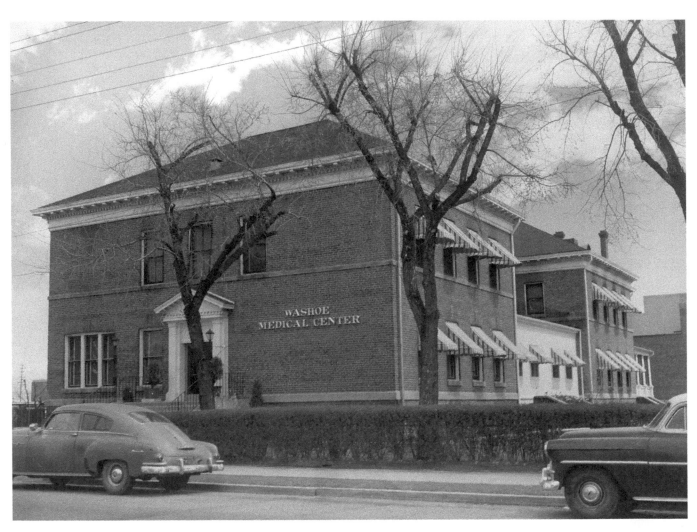

The Washoe Medical Center in 1957, one of Reno's two major hospitals.

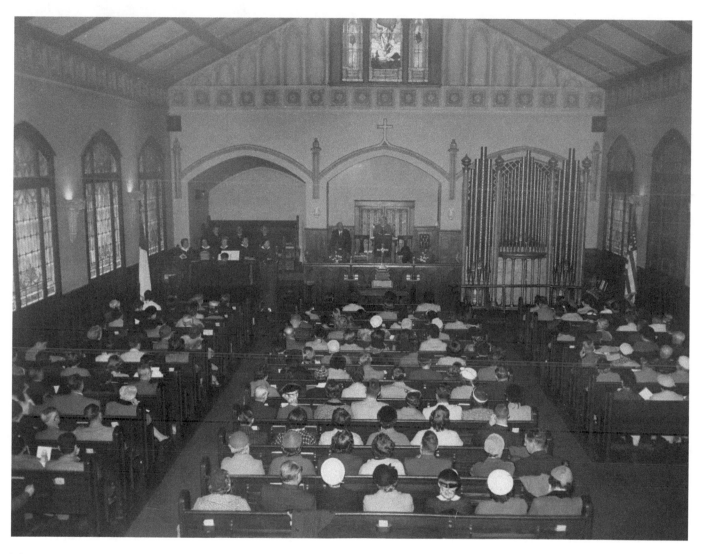

The First Baptist Church interior during the "decommissioning service," January 19, 1956. The church was built in 1918 and sold in 1956.

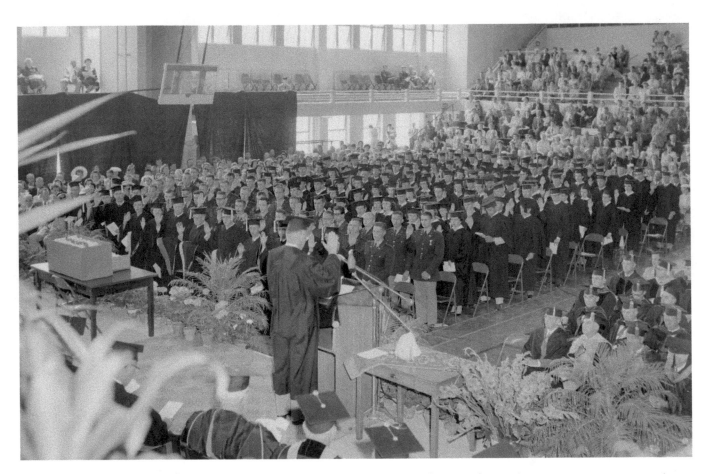

Justice Charles M. Merrill of the Nevada Supreme Court swears in the new graduates at the 1956 commencement ceremony in the gymnasium of the University of Nevada in its last year as Nevada's lone university. The new Las Vegas branch first help classes in 1957 and eventually attained its autonomy in 1968. When that school became the University of Nevada, Las Vegas in 1969, the Reno institution lengthened its name to the University of Nevada, Reno.

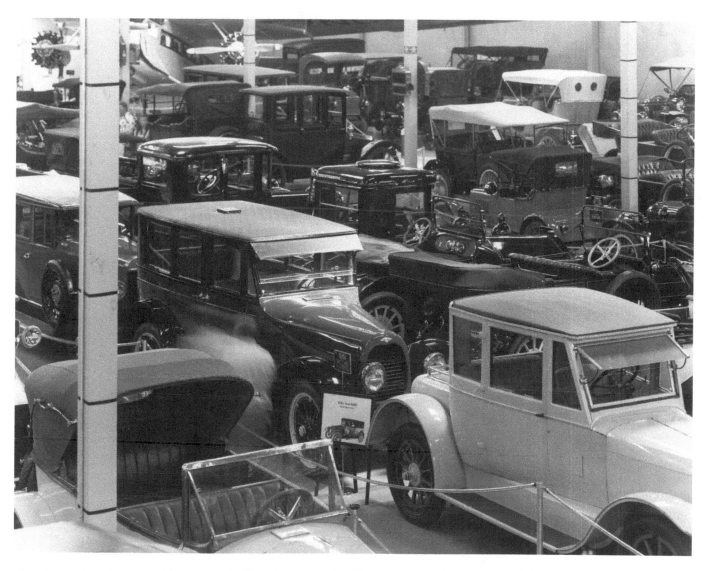

Bill Harrah bought a small bingo parlor in Reno in 1937 and built it into a gambling empire. While most of his profits went into expanding the business, his passion for automobiles resulted in a collection of 1,400 classic vehicles, some of which are shown in this Sparks warehouse. After Harrah's death, most of the collection was sold, but 175 of his vintage autos became the basis for Reno's National Automobile Museum.

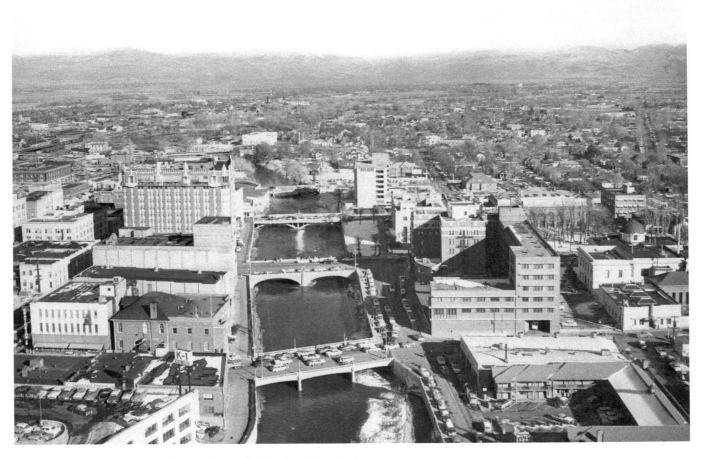

An aerial photo of Reno, April 1957, shows the Truckee River in the center.

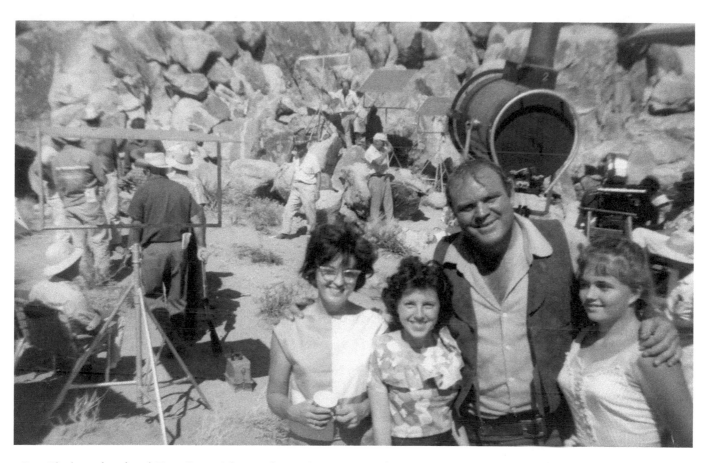

Dan Blocker, who played Hoss Cartwright on television's *Bonanza*, with visitors on the set of the Ponderosa Ranch between Reno and Lake Tahoe in the 1960s. Episodes from the last five years of the show were filmed here. The Ponderosa was operated as a theme park from 1967 until 2004.

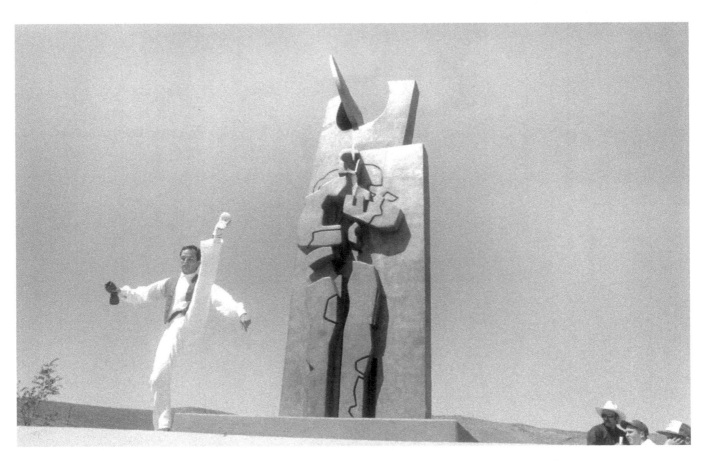

The Basque Sheepherder statue honors the Basques who first came to Nevada from France and Spain to herd sheep in the 1800s and continued that tradition into the 1970s. Once in Nevada, Basques frequently succeeded in ranching and other realms. The most prominent Basque Nevadan was Paul Laxalt, a governor and U.S. senator. His brother Robert wrote *Sweet Promised Land,* a powerful story of their father's emigration.

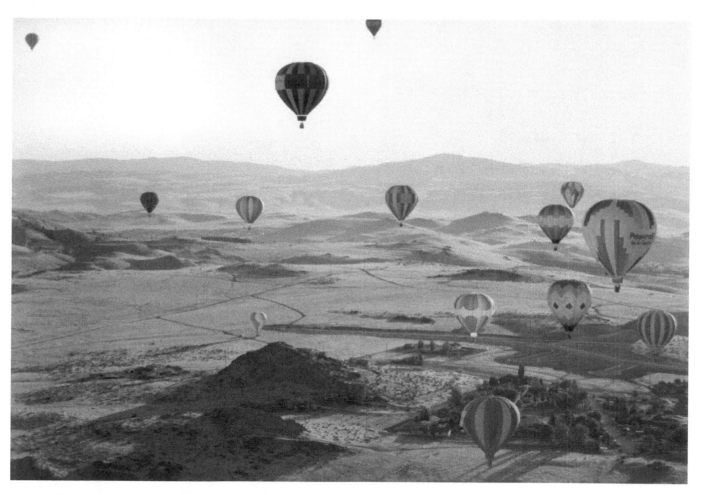

The Great Reno Balloon Race began in 1964 as part of the Air Races program but was discontinued after a couple of years. Revived in 1981, it is now held each September. Other transportation-themed festivals that draw large crowds are Hot August Nights for classic car enthusiasts, Street Vibrations (a gathering of motorcyclists), and the Reno Air Races in September.

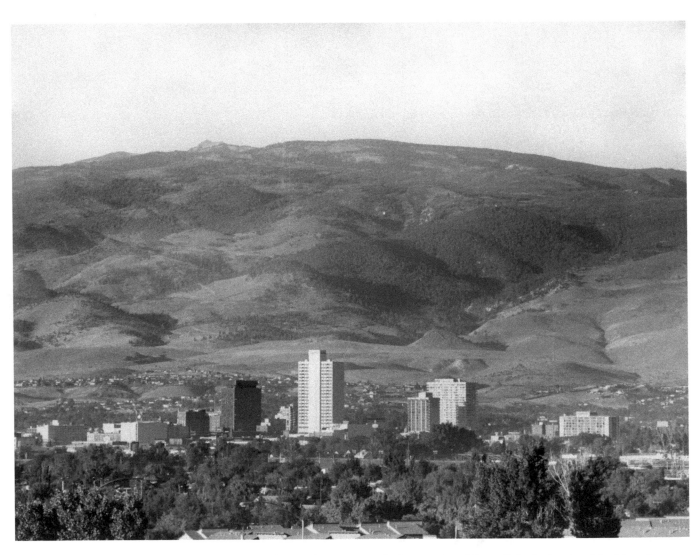

The Reno skyline in the 1970s shows how far the former frontier town had come since Myron Lake built a hotel beside a river crossing during the 1860s silver rush.

Notes on the Photographs

These notes, listed by page number, attempt to include all aspects known of the photographs. Each of the photographs is identified by the page number, a title or description, photographer and collection, archive, and call or box number when applicable. Although every attempt was made to collect all data, in some cases complete data may have been unavailable due to the age and condition of some of the photographs and records.

9 781683 368779